Happy Birthday - Marie
Love
Duane & Sally
4/98

Happy Birthday - Marie
Love
Duane & Sally

GETTING STARTED IN
WATERCOLORS

Brian and Ursula Bagnall • Astrid Hille

WALTER FOSTER PUBLISHING, INC.
Laguna Hills, California

Published by Walter Foster Publishing, Inc.,
23062 La Cadena Drive, Laguna Hills, CA 92653.
All rights reserved.
English translation copyright © 1994 Joshua Morris
Publishing, Inc., 355 Riverside Avenue, Westport, CT 06880.
Produced by Joshua Morris Publishing, Inc.
© 1993 by Ravensburger Buchverlag Otto Maier GmbH.
Original German title: *Anfangen mit Aquarell.*
Cover painting by Brian Bagnall.
Printed in Hong Kong.

ISBN: 1- 56010-179-2
10 9 8 7 6 5 4 3 2

Contents

About This Book

It's not surprising that watercolors have become one of the most popular media of the hobby painter today. In a time when everything seems to move quickly, effective watercolor paintings can be produced in a relatively short time and with very little expense or effort.

However, behind this ease of use lurks a problem. What is initially attractive about painting in watercolors—namely, the spontaneous textures, the expressive paint-runs, and the pure, transparent colors—can later lead to difficulties. For example, the paint may run just at the moment it shouldn't, or a mixture may result in a muddy gray-brown instead of a beautiful violet. Besides, how can one intentionally produce something that arises spontaneously and coincidentally?

Chock-full of useful, practical information and instruction, this book will help you solve the common problems faced by beginning watercolor painters. It will help eliminate your fear of the empty canvas (in this case, blank white paper), inspire you to experiment, and show you that accidents (what you think are mistakes or sloppy painting) can often result in something satisfying.

Because you're just starting out in watercolor painting, the focus here is on a basic supply of colors and materials. You'll be amazed at what you can achieve with so little. Using the step-by-step illustrations, you can learn how different artists go about producing paintings. In addition to all this, you'll discover how much fun it is to experiment with watercolors.

For right now, don't worry about becoming a J.M.W. Turner, an Emil Nolde, or a Pablo Picasso. Just develop your own ideas, use your own imagination, and follow the several practical tips offered on pages 37 and 58-59.

Because every artist hopes to develop a unique style, it is important for you to see more than just one way of painting. This is why every step-by-step example has been contributed by a different painter. In this way, you can become familiar with different approaches to watercolor painting and decide for yourself which you prefer.

The most important thing to remember is to have fun!

Brian Bagnall

Brian Bagnall is the art director of the Artist's Workshop series. Through his firsthand experiences as an art professor in England, he knows what art students enjoy and what they find difficult.

Born in 1943 in Wakefield, England, Brian Bagnall studied painting and etching, completed his National Diploma with honors, and taught a printmaking workshop at his college. He then moved to Amsterdam, where, in addition to teaching, he worked for many publishing houses and advertising agencies. He was also active for many years as a professor in Darmstadt, Germany.

Since 1970, Brian Bagnall has lived in Munich, where he and his wife, Ursula, opened Bagnall Studios, featuring a broad spectrum of work. He has written many books, and his work has been exhibited all over Europe and Korea.

Astrid Hille

Astrid Hille is the editor of the Artist's Workshop series and works closely with Brian Bagnall and his wife.

Hille was born in 1955 in Hamburg, Germany. There, she completed training as a technical illustrator at the Fachhochschule für Kunst und Gestaltung and went on to study illustrating and painting. Afterward, she worked as an illustrator and painter, as well as an art teacher in adult education. Since 1982, Hille has lived in Freiburg, Germany. She completed a second college degree in multimedia education and has been a proofreader of art books and children's books since 1985.

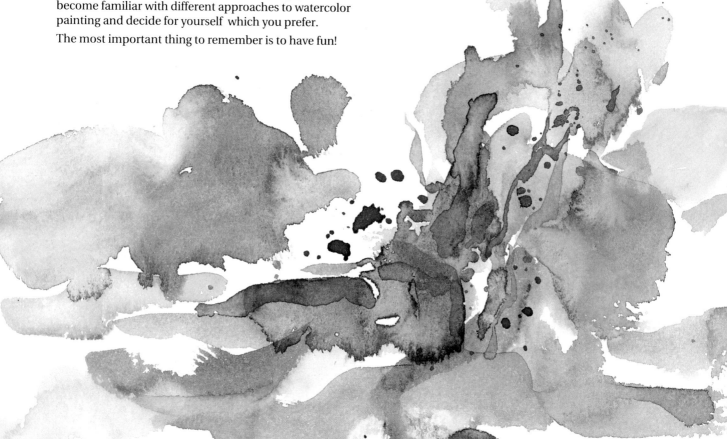

Ursula Bagnall

Ursula Bagnall is responsible for the text and layout in the Artist's Workshop series. She brings together the artists' outlooks, illustrations, and explanations into a well-organized presentation.

Born in 1945 near Munich, Germany, Ursula Bagnall completed her training in graphic design at the Akademie für Graphisches Gewerbe, in Munich. Afterward, she worked with Otl Aicher on projects for the 1972 Olympic Games and later took teaching positions at American schools in Amsterdam and Munich. Since 1973, she has worked with her husband, Brian, as a free-lance graphic artist and author. They have written many books together, among them several art instruction books for children and adults.

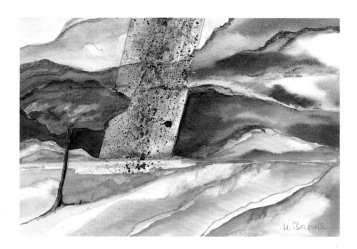

Karlheinz Gross

Karlheinz Gross shows you step-by-step how to create a watercolor painting of a village.

Born in 1943 in Harz, Germany, Gross studied at the Werkkunstschule A.L. Merz, in Stuttgart, Germany. He later took courses in commercial art and illustration under Professor Robert Förch at the Gutenbergschule, also located in Stuttgart. In 1966, he opened his own studio in Bietigheim-Bissingen, Germany, and has since worked as a free-lance graphic artist and painter.

Gross teaches classes in watercolor painting, but most of his time is spent painting for his own enjoyment. Since 1971, his work has appeared in many solo exhibitions.

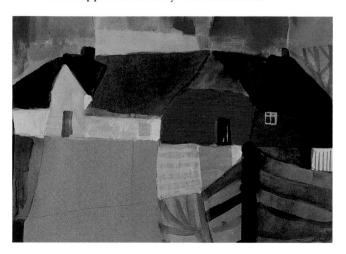

Gerlinde Grund

Painter and graphic artist Gerlinde Grund teaches you how to paint flowers.

Also an expert decorator, Grund studied commercial art in Offenbach, Germany, and graphic design and painting at the Akademie für bildende Künste in Stuttgart. She has considerable experience as a working commercial artist—first in Frankfurt and later in Freiburg, Germany. Since 1981, Grund has been a free-lance painter and graphic designer in Freiburg. She also teaches courses in watercolor painting and has recently begun teaching summer courses in such countries as Italy, France, and Switzerland. Her work has been exhibited throughout Germany.

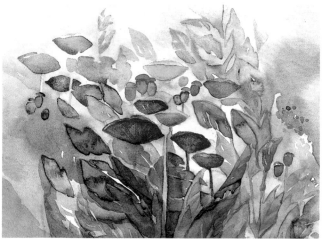

Beate Weber-von Witzleben

Beate Weber-von Witzleben focuses on still life painting in watercolors.

Weber-von Witzleben was born in 1953 near Lake Constance, Germany. Before studying German philology in Freiburg in 1973, she was actively involved with painting, poetry, and theater. After completing her studies, traveling, and exhibiting, she began an intensive study of East Asian painting. Since 1979, Weber-von Witzleben has taught painting and drawing and written a book on watercolor painting. She has also had many exhibitions, including one in Tokyo.

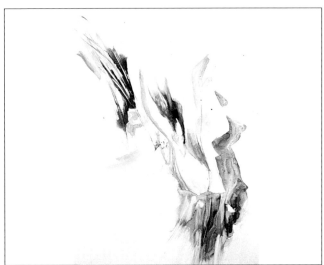

Watercolor Painting—Yesterday and Today

Some might think that watercolor painting is a typical product of our fast-paced world, where even hobbies shouldn't take too much time. Actually, the opposite is true. Watercolor is, in fact, one of the oldest painting media. Prehistoric people simply used what they had, mainly materials easily found in nature. Clay, soil, and minerals were made into pigments, mixed with water, and used as paint. Eventually, people began to include other materials, such as egg and gypsum, and only after extensive experimentation did they discover that oil could be used as a base for paints.

Strictly speaking, the early frescoes of the Egyptians and the cultures of the

In the early 1800s, English artists, such as John Sell Cotman (1782-1842), J.M.W. Turner (1775-1851), and John Constable (1776-1837), brought the medium of watercolor painting to an unprecedented height. It was during this period that artists began to stretch their paper. They soaked it and then attached it to a solid surface so it would be stretched tightly after it dried. Even today, this process provides the best surface for painting in watercolors.

Later, the Impressionists and the Expressionists—for example, Emil Nolde (1867-1956), Paul Klee (1879-1940), and Lyonel Feininger (1871-1956)—became very interested in watercolors.

paints and to plan how the colors run together. In other words, you simply have to experiment and become comfortable with the materials.

There are tricks and other aids that can make painting in watercolors easier for you. Working with watercolors, however, does have one characteristic in common with other painting media: it is fun to explore all the different possibilities watercolor offers.

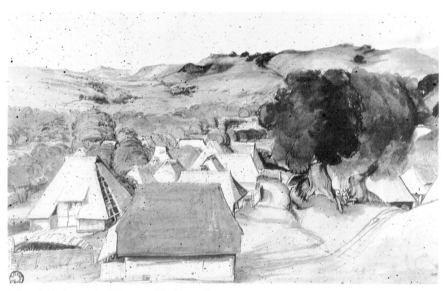

Albrecht Dürer, *The Village of Kalchreuth*

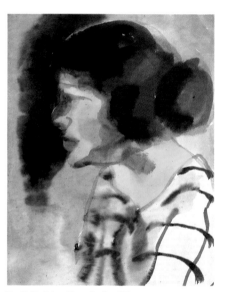

Emil Nolde, *Head of a Woman*

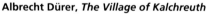

Mediterranean are a form of watercolor painting. The Chinese and Japanese also used water-based paints for their parchment scrolls and paintings.

Even Albrecht Dürer (1471-1528), one of the greatest artists of the northern Renaissance, painted in watercolors, although at that time oil paintings enjoyed greater prestige and were considered the only "proper" pictorial art. Watercolors were used merely for sketches and to prepare the color scheme for the final oil painting. It wasn't until the eighteenth century that watercolor painting reached its golden age and began to grow in popularity.

Watercolor painting has increased in popularity mainly because the paints are easy to use and allow quick results. Moreover, the paper and supplies are easy to carry, and water can be found almost anywhere. It's no wonder, then, that so many people consider watercolor the easiest painting medium in which to work.

Of course, this observation is similar to saying that tennis is easier to play than golf. The ease of painting in watercolors is exactly what makes the medium so difficult. You have to learn how to handle accidents (not try to correct them) or to make them happen intentionally. You also have to learn how to use the transparency of the

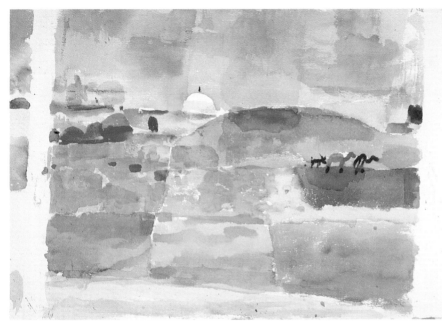

Paul Klee, *Before the Gates of Kairouan*

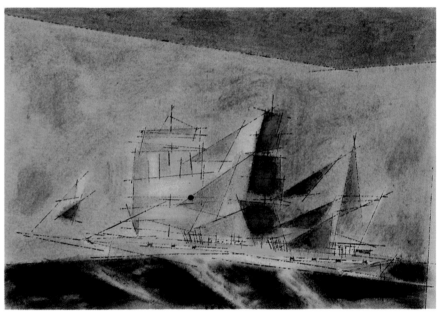

Lyonel Feininger, *Vision of a Bark*

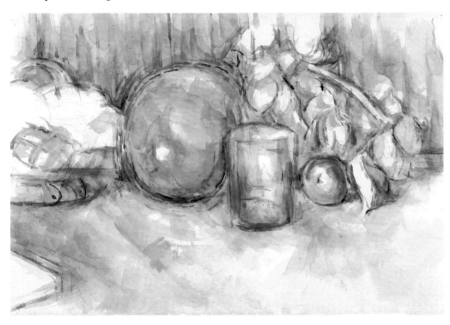

Paul Cézanne, *Still Life—Green Melon*

Choosing Materials

In painting, it is important to have the right supplies. As a rule, it is best to buy high-quality materials, even if it means buying fewer of them.

Selecting Paints

You can use paints in tubes or in pans; both types are available individually or in sets. Experiment with both to decide which you like better. Sets are convenient because you can store your brushes inside the box and use the lid as a palette. The disadvantage is that they often come with colors that do not necessarily mix well. Many art supply stores, however, will substitute colors. The most important colors are chrome yellow, cadmium yellow light, cadmium red light, alizarin crimson, cerulean blue, and ultramarine blue (there is more information about colors and color combinations on pages 11 and 12).

Tube paints are more opaque and more brilliant than pan colors. If you accidentally squeeze too much paint out of the tube, don't worry about it. Simply leave the paint on the palette; you can add water to the dried paint and use it next time.

You have to add water to pan colors each time you use them. Also, remember to leave space between the individual pans in the paint box; otherwise, the paints can run together.

Selecting Brushes

The same rule that applies to paints applies to brushes. That is, it's better to buy a few high-quality brushes than a lot of cheap ones. Choose genuine sable brushes (sometimes called red sable or kolinsky sable). If you plan to paint standard-size pictures—that is, no oversize or miniature paintings—one thick brush and two thinner ones will probably suffice. A number 10 (somewhat thicker), a number 6, and a number 3 brush are recommended. You may also want to buy several inexpensive brushes to paint backgrounds or to work out rough areas of your paintings.

When you're not using your brushes, roll them up in a bamboo mat (see the photo below). In this way, you can protect them from dust and keep the delicate tips from getting bent. Rolling brushes up in a mat also makes them easier to carry. If you don't plan to work with your brushes for a while, store them in a drawer or closed container. Otherwise, dust can build up in the tips and cause them to fray. After each use, clean your brushes thoroughly, using soap if necessary. Shake them afterward (do not squeeze them), and allow them to air-dry.

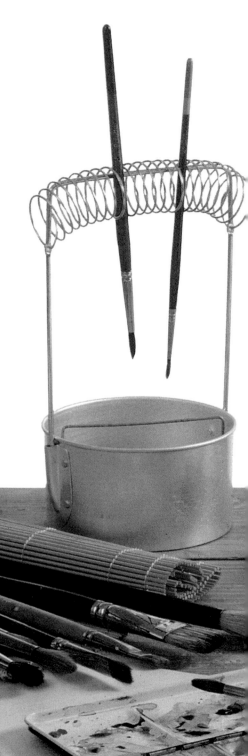

Selecting Paper

Paint reacts differently on different kinds of paper. Consequently, the texture of the paper is very important because it influences the behavior of the paint. You can see this very clearly in the example to the right. The simplest thing to do is get some samples from an art supply store and experiment with different paper textures.

You can buy watercolor paper in blocks or individual sheets. Because the paper buckles when it gets wet, you have to stretch the single sheets on a board and tape down the edges. The blocks are bound along all four edges to prevent the paper from curling up as you paint; therefore, you may want to use the blocks because they are easier to paint on and to carry.

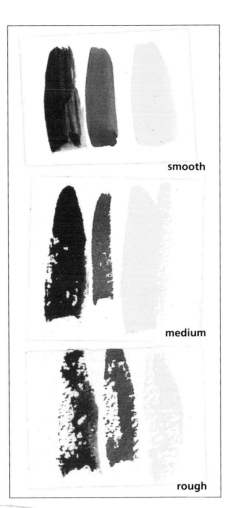

smooth

medium

rough

Odds and Ends

Now you need a water container or, better yet, two: one for cleaning brushes and one to dip into as you paint. You'll also need a towel or tissue to blot up excess paint and a small sponge to create certain textures.

You can use the lid of the paint box or a small metal palette as a surface for mixing paint. There are also palettes made of individual sheets of water-repellent paper that you can tear off when you're finished with them (see the picture below, under the plastic palette).

With a few additional items, you will be well equipped for watercolor painting. A brush holder, such as the one pictured here, is practical because it allows the excess paint and water to drain off. (Never leave your brushes standing in water.) You'll need a soft pencil for preliminary sketches. Try to avoid erasing because it can damage the paper and result in unattractive areas when you paint over the erasure. Finally, if you plan to work with extensive white areas, you'll need liquid frisket or some other kind of masking material.

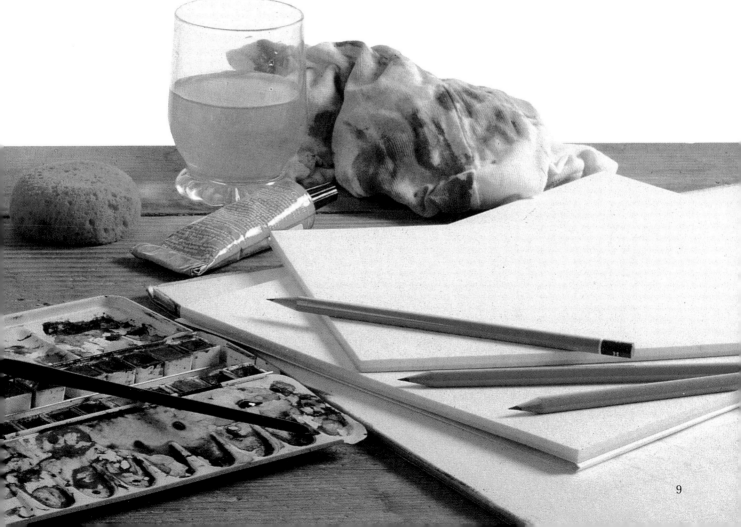

Selecting and Mixing the Basic Palette

At first, you won't need to buy many colors. It is important, however, to buy the right colors so that you can mix them to make other colors. If you mix the wrong colors, you'll only get muddy browns and grays.

In the box below, you can see the colors you'll need for your basic setup.

(If you buy a set of paints, make sure it contains all these colors.)

Practice mixing these colors in all possible combinations. You'll be amazed at how many hues you can come up with, and you will also get an idea of what is possible with a limited palette. You may want to use scrap sheets of paper or the backs of "accidents" (sheets with mistakes on them) to do your experimenting.

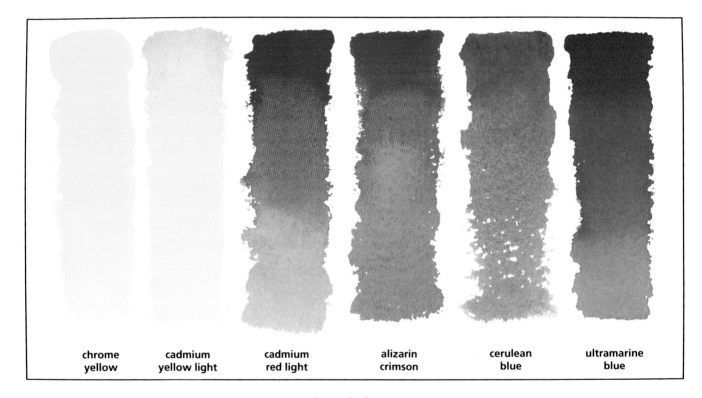

| chrome yellow | cadmium yellow light | cadmium red light | alizarin crimson | cerulean blue | ultramarine blue |

If you want to expand this basic palette, you should consider how well the colors will mix before you buy any new paints. A few colors that can be incorporated into the basic setup are recommended below. Note: The darker value at the top of the swatch corresponds to the undiluted paint.

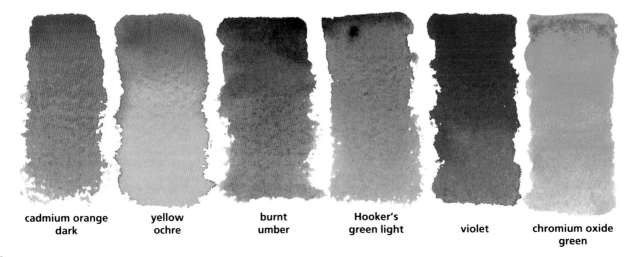

| cadmium orange dark | yellow ochre | burnt umber | Hooker's green light | violet | chromium oxide green |

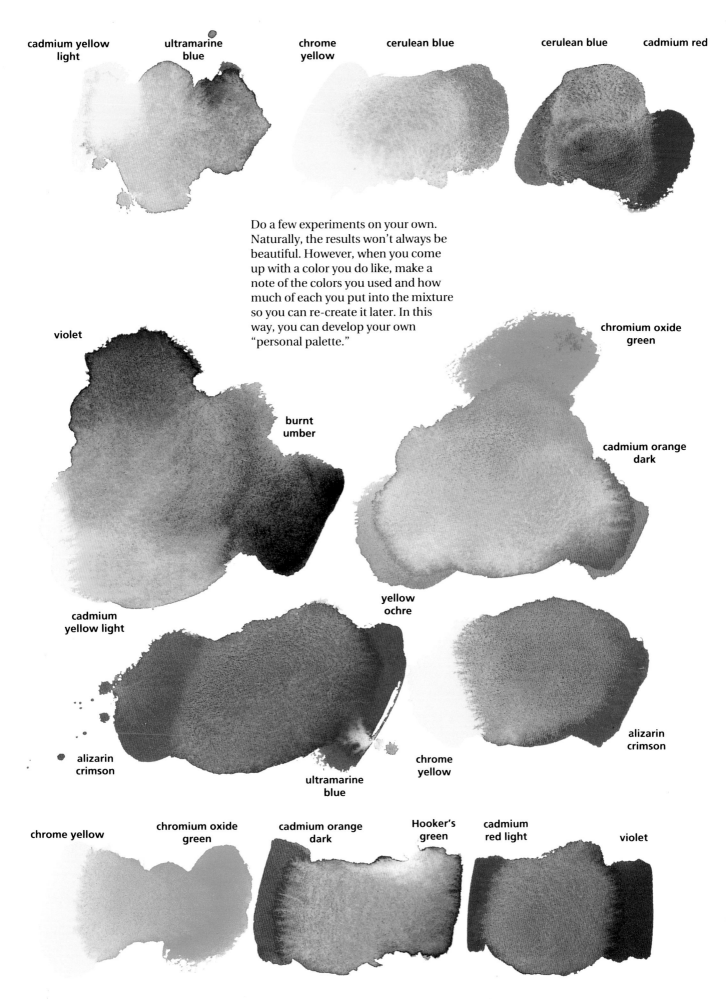

cadmium yellow light **ultramarine blue**

chrome yellow **cerulean blue**

cerulean blue **cadmium red**

Do a few experiments on your own. Naturally, the results won't always be beautiful. However, when you come up with a color you do like, make a note of the colors you used and how much of each you put into the mixture so you can re-create it later. In this way, you can develop your own "personal palette."

violet

burnt umber

chromium oxide green

cadmium orange dark

cadmium yellow light

yellow ochre

alizarin crimson

ultramarine blue

chrome yellow

alizarin crimson

chrome yellow **chromium oxide green**

cadmium orange dark **Hooker's green**

cadmium red light **violet**

11

Basic Techniques

The unique features of watercolor painting are the transparency of the colors and the spontaneity of the medium. More than with other painting media, watercolors allow you to improvise and rely on your own creativity when you apply the paints. All watercolorists have their own little "discoveries" and tricks. You have to be careful right from the beginning, however, not to overdo it. This means not letting too many different colors run together and not painting too often over the same spot. Both of these mistakes usually result in muddy hues, which destroy the appeal—the freshness—of the colors. In spite of all the freedom you have in watercolor painting, you still should try to master some of the basic techniques. This section deals with the most important techniques. Experiment with them on some scraps of paper at first.

Working Wet-in-Wet

There are two ways of working wet-in-wet:

1. Wet the entire sheet of paper with a sponge or thick brush and then apply wet paint. Every mark will blur softly, so there won't be any hard edges or lines. Be careful when you wet the paper; if you rub too hard, you can roughen it, and roughening will create unattractive textures in the paint.

2. The example to the right shows the second method of working wet-in-wet. The artist thinned the paint with a lot of water and applied it directly on a dry background. In this technique, the wet paints intermingle, but they stop at the dry areas of the paper, resulting in sharp edges.

Working Wet-on-Dry

Using this technique, you can paint sharp forms on a dry background, as shown in the example at the left. If you are painting over a colored background, first let the background paint dry, and then apply wet paint on top of it. You can also get some interesting effects with a dry brush.

Keep in mind that the effects change, depending on the wetness of the paper. If the background is not quite dry, the paint will blur and the lines will appear fuzzy.

Experiment with these different techniques, starting with wet paper. Then paint on it every few minutes so that the paper is slightly drier each time you paint. You'll see that each stroke reacts differently.

Applying Glazes

Glazing is a transparent form of painting in which one color is visible through another. With this technique, you work on a dry background—that is, you let one layer of paint dry before you apply the next.

Actually, watercolor painting itself is a glazing technique because the colors aren't opaque. When you intentionally use glazing, you have to be careful that the dry colors do not wash off when you paint over them, so don't use too much water, and try to paint relatively quickly over areas that already have paint on them.

Here, the same subject was painted using the three different techniques:

The entire flower was painted wet-in-wet, creating a blurred effect. The large leaf was painted last on a relatively dry background.

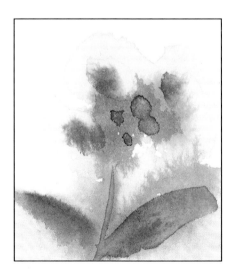

Here, the artist painted the yellow and red petals of the flower and the green background, allowed them to intermingle, and left them to dry. The detail lines and the leaves were added last, after the paint was dry.

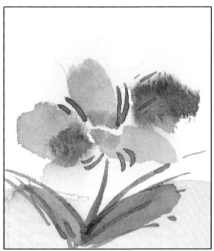

Notice that the flower below appears to have more depth. The glazing technique was used for this example; every color shines through, giving the flower a much fuller effect.

Applying Washes

The Flat Wash

Simply allowing the paint to flow freely is much easier than trying to apply an even layer of color over an area, but you need to be able to do this to paint things such as a clear sky, calm water, or a smooth wall. The best way to paint an area with no tonal variation is to apply a flat wash. This technique is not difficult, but you will need to practice to get it right.

First, wet the area of the paper where you want to apply the wash. You can do this with a thick brush, a sponge, or a washcloth. (If you use a washcloth, be sure that you don't rub the paper too hard, as this results in rough areas where pools of paint can collect.) Next, working in one direction, apply a wash of color across the top of the area to be covered. Then reload the brush and apply a wash directly below the first, this time in the opposite direction. (See illustration below.) Work from top to bottom until the entire area is covered. Note: Tilt the paper slightly so the paint flows downward.

You may want to experiment with small areas at first so you can get a "feel" for the way the paint reacts.

The Graded Wash

A graded wash is also done with just one color of paint but has variations in

tonal intensity. Again, place your paper at a slight angle so the paint runs downward. Then begin applying the paint with even strokes at the top of the page, working your way toward the bottom and using less color and more water.

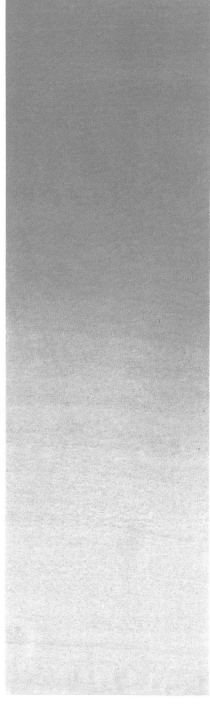

Always work from dark to light because it's easier to reduce the amount of paint than it is to increase it. (See illustration above.) If you want to have the light part of a graded wash at the top of a painting, simply turn the paper upside down while you're painting.

The degree of contrast and tonal intensity in a graded wash depends on the amount of water in the paint. A wash containing little water will be dark; a wash with more water will be lighter.

The Variegated Wash

As in the case of the other washes, first wet your paper, making sure that the area where you want the two colors to flow together is particularly wet. Then begin at the top, work your way to the middle, and stop. To apply the second color, turn your paper upside down and repeat the process, allowing the second color to flow into the first color in the center. (See the illustration below.)

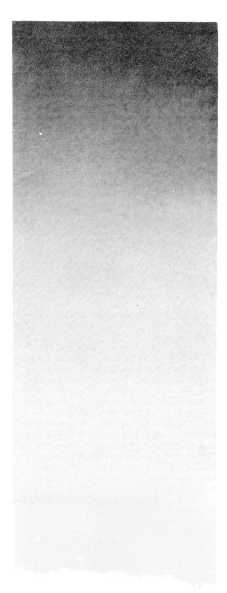

Tilt the paper as needed to guide the colors together. This technique is a matter of practice. Finally, be sure that your water and brushes are clean.

Brushwork

When a line is drawn with a soft pencil, the line will change, depending on how much pressure you apply with your hand. With brush strokes, the result is even more pronounced because of factors such as the wetness of the paint and the amount of paint on the brush. You can see this in the comparison of the two marks below.

Practice with different brushes by drawing lines of differing thicknesses. Relax your hand and experiment. The painting below should give you some ideas. For this example, the artist used a thick brush (number 6) and a thin brush (number 3). You can see very clearly which marks were made with a brush containing mostly water and

which ones were made with a brush containing mostly paint. You can also see the different ways in which thick and thin brushes can be used. Always keep a piece of scrap paper handy so you can "warm up" before actually touching your painting.

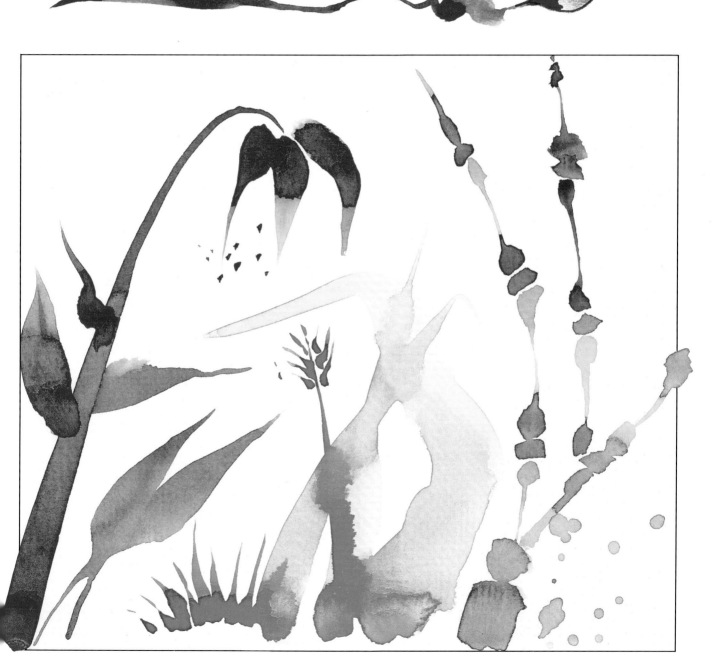

15

What Colors Tell Us

A picture's mood depends not only on the motif but also on the colors that are used. By simply varying the colors, you can make an autumn scene express either happiness or melancholy. Similarly, a crying child with red cheeks doesn't seem nearly as sad as one with a pale face.

It is important to understand the difference between warm and cool colors. Have you ever felt particularly chilly in a blue room or unusually comfortable in a yellow room? If so, there is a good reason for it. Blue reminds us of snow and ice; therefore, we associate blue with cold temperatures.

Conversely, the sun and objects on which it shines have a yellow effect; therefore, we associate yellow with warmth. Neutral colors, such as red-violet or yellow-green, also exist but are difficult to categorize as "cool" or "warm."

Compare the two palettes below. Although they both include red, yellow, blue, and green, the one on the left has a warmer effect overall than the one on the right. This is because of the quantities of red and blue in each color. The colors at the left contain more red, whereas the colors on the right contain more blue.

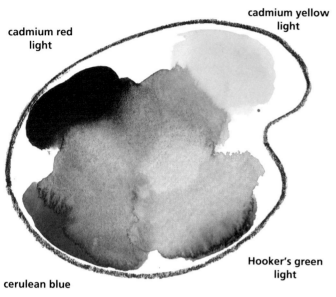

cadmium red light

cadmium yellow light

cerulean blue

Hooker's green light

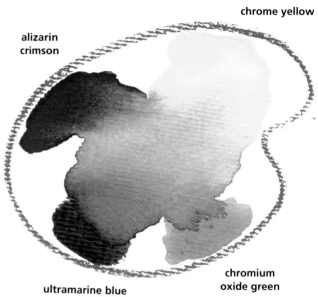

alizarin crimson

chrome yellow

ultramarine blue

chromium oxide green

Let's look at the role of color in a simple landscape. In the painting at the left, the trees and sky have a cheerful, springlike effect. The bright, warm tones dominate and set the mood of the painting. The four colors were applied on a dry background with the use of a lot of water.

This painting of the same motif was also painted on a dry background, but this landscape appears significantly gloomier and colder because the darker colors determine the mood. You can see that the yellow and red do not bring any warmth to the painting because they contain a large quantity of blue.

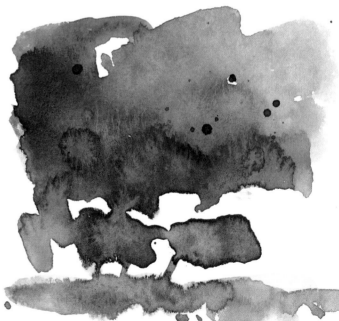

16

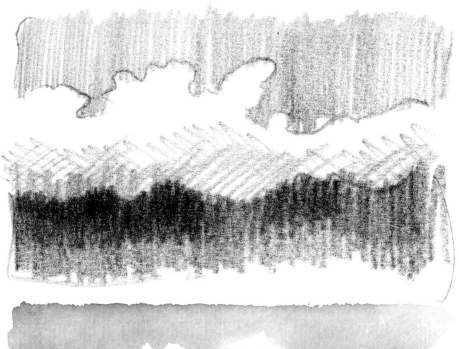

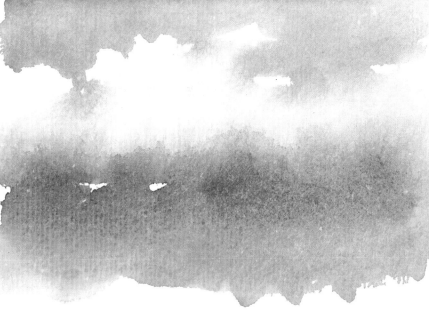

Painting the Sky and Clouds

Both cool and warm colors play a role in paintings of skies and clouds. Consider the differences between a summer thunderstorm and a winter snowstorm. Achieving these effects in paintings is not so much a matter of reproducing the exact shape of the clouds as it is of reproducing the mood. There are many ways to paint clouds, but it is not always easy to capture on paper the fascinating cloud formations that you see in the sky. Unfortunately, there is no secret recipe. Only practice and experimentation can help you improve.

Take some time (without your paints) to just look at the sky and the clouds. You'll usually see some white areas, even when the sky is overcast. Most of the time, clouds are dark on the bottom and gradually get lighter toward the top. It may help you to make a black-and-white sketch before you start to paint, as shown here at the top of the page. By doing this, you can work out the value scales, and it will be easier to compose the dark and light areas in the final painting. Be sure, however, that you sketch as little as possible on your actual painting because the pencil marks show through and detract from the picture.

In the example at the left, the paper was wetted first. Then, on this wet background, the artist allowed the paint to run from the bottom and the top into the white area in the middle. These colors, gently fading toward the center, give the cloud a soft effect.

Another option is to apply the wet paint and then immediately lift out the white clouds with a tissue. If you allow the paint to dry slightly before you lift it, some of the color will remain in the cloud, giving it a softer effect. Try a few variations on scrap paper.

Above: Cerulean blue was used at the top of this painting and allowed to run down into the white area. The bottom was painted with ultramarine blue, burnt umber, and a touch of chrome yellow.

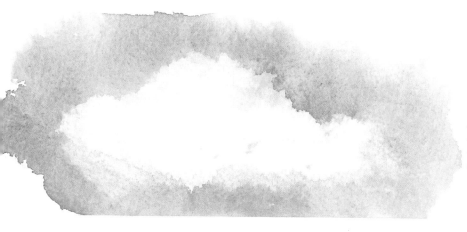

Left: In this example, ultramarine blue was used at the top and cerulean blue at the bottom. The delicate areas of blue in the cloud were created by gently lifting out the paint with a tissue.

17

For Practice

All of the most important watercolor techniques were used for this simple landscape. Practice creating a few color sketches using these techniques. Remember, the only thing you have to lose is a sheet of paper!

Wet-in-Wet

Here, instead of wetting the paper first, the artist simply applied two different colors to dry paper. The wet paints intermingle in the center. You can see this effect in the example at the right, as well as in the sky and the meadow of the painting on page 19. If you end up with white areas in the sky, you can make them into clouds.

Wet-on-Dry

If you let the edges dry before applying the second color, you can create crisp, sharp lines. This technique is good for horizons, as demonstrated in this painting, or any areas where you need to distinguish sharply between colors.

White Areas

The white areas of a watercolor painting should be planned from the beginning. There are two ways to do this:

1. Simply paint around the area, as the artist did here for the building. This requires some practice, though, to prevent the paint from pooling up at the edges.
2. You can cover the area with liquid frisket. You should use an old brush to do this because it is difficult to completely remove the frisket from the brush. Once the frisket is dry, you can paint over it. When the paint is dry, rub the frisket off and do as you please with the white surface underneath. Note: Be careful when using frisket on rough paper because the frisket may not completely cover the surface and the paint can run into the white areas.

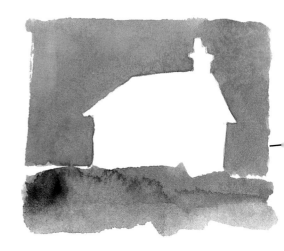

Details

Adding detailed shapes and contours to the dry painting is the final step. Brush exercises such as those described on pages 14 and 15 can help you practice this technique. Here the artist added the blades of grass and the tree. Blurry areas can occur if the paper is even slightly wet. This can help make the picture appear more three-dimensional.

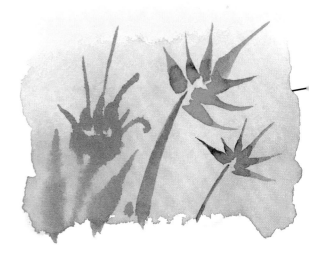

Colors Used

ultramarine blue
yellow ochre
burnt umber
chromium oxide green
cadmium yellow light
alizarin crimson
Payne's gray

Brushes Used

number 10, number 5, and
number 3 round sables

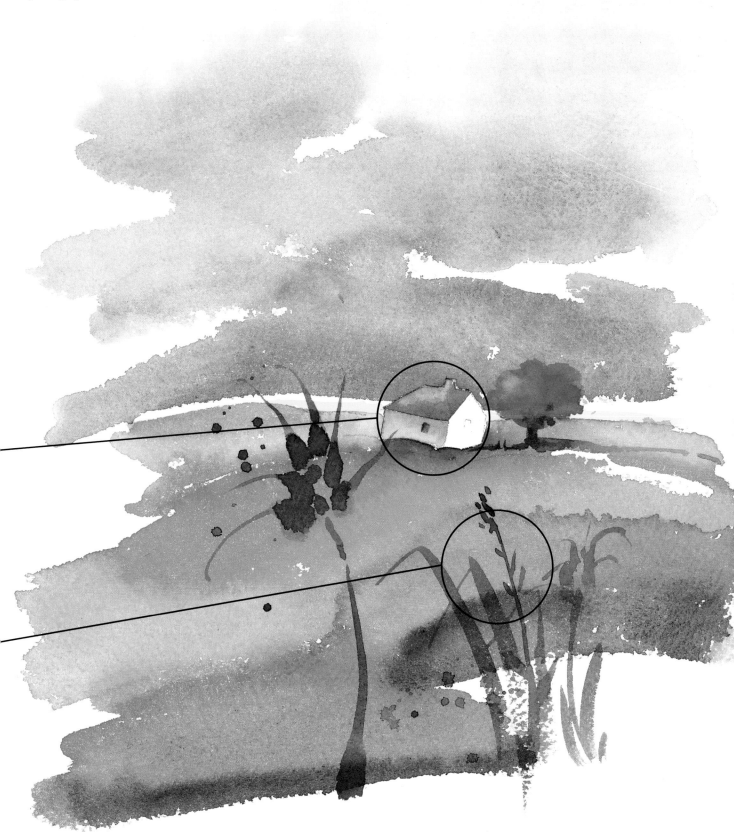

Learning to See

Does the title of this section seem strange to you? You might think you can already "see." However, two people standing before the same view will see different things—namely, those things that are important to them personally. For example, an artist who looks at a field may think of an interesting landscape motif, while, on the other hand, a farmer may notice only the ripeness of the grain.

The transfer and simplification of the things you see are not easy. Almost everything, however, can be broken down into five basic shapes—a point to keep in mind when you're sketching a motif. These five basic shapes, shown below, are the square, the triangle, the circle, the oval, and the rectangle.

You can see the basic shapes in these examples. Try to forget about three-dimensionality and concentrate on the basic shapes.

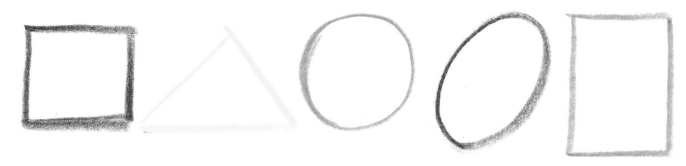

Painters need to transfer what they see onto paper. To do this, they must reduce it. Also, because they can't paint every individual leaf of a tree, they have to concentrate on the overall form.

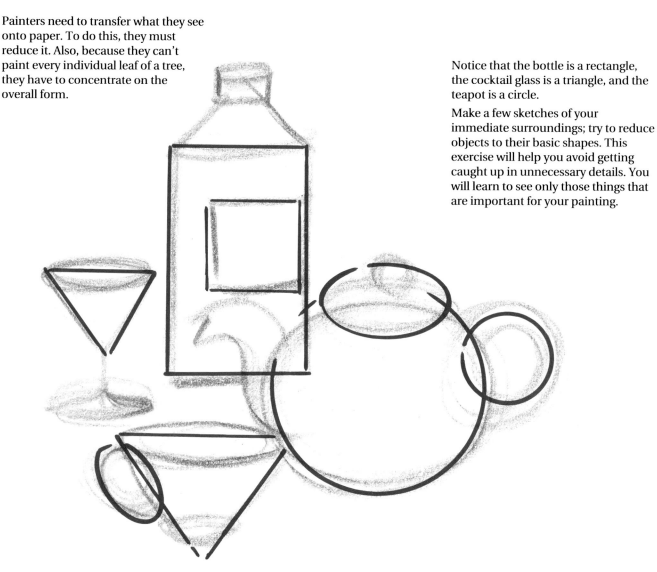

Notice that the bottle is a rectangle, the cocktail glass is a triangle, and the teapot is a circle.

Make a few sketches of your immediate surroundings; try to reduce objects to their basic shapes. This exercise will help you avoid getting caught up in unnecessary details. You will learn to see only those things that are important for your painting.

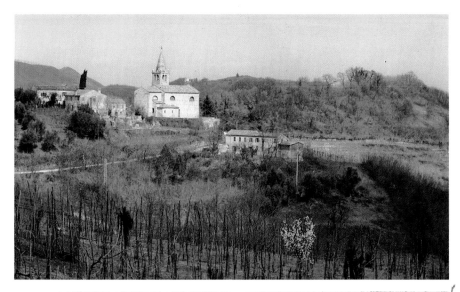

Let's look at another example of reducing objects to their basic shapes. Here is a photograph of a typical landscape. Notice, however, that the composition isn't particularly exciting: there is too much green, and the buildings are too far in the background.

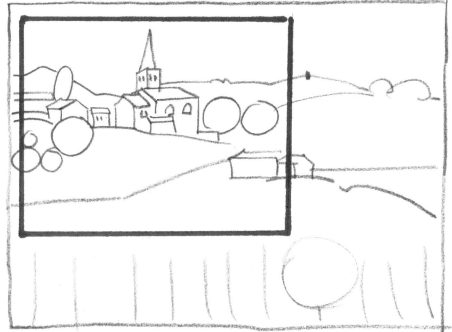

Begin by reducing the scene to basic shapes. This will help you determine which elements are important for the composition and which ones you can leave out. Notice the basic shapes: the circle, the rectangle, the triangle, and the oval. (Of course, there are other shapes, but the basic ones serve as a foundation.)

Practice breaking down uncomplicated photos into simple black-and-white sketches. Bear in mind that your composition is allowed to deviate from reality. Learn to view nature as an inspiration and not as a required exercise in faithful reproduction. If a fence or a post bothers you, leave it out. If you think a tree is too small for the composition, make it bigger.

There are many ways of arranging this scene. Here the artist moved the church to the center and left out a large part of the vineyard. The building in the foreground was distracting, so it was left out as well.

What would you do with this photo?

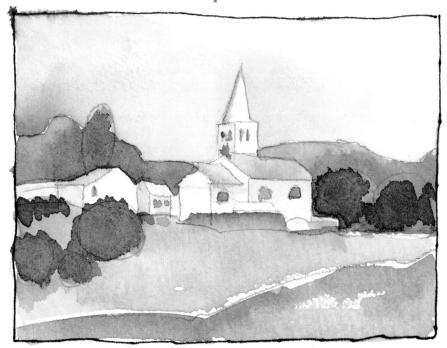

Positive and Negative Space

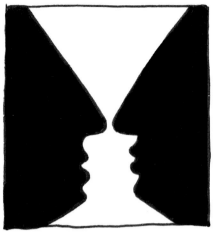

The selection of the motif is not the only factor to consider in the composition. It is also important to consider the interplay of shapes. Negative space, which is the space between objects, plays just as large a role in the composition as positive space, which is the space occupied by objects. Look at the picture to the left. Do you see two profiles or a vase? If you let your eyes relax, the motif will change. Here the positive space and the negative space are balanced—that is, they have equal weight in the composition.

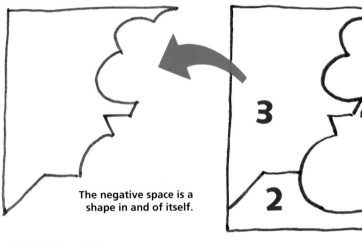

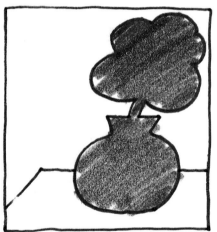

The negative space is a shape in and of itself.

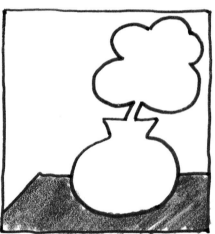

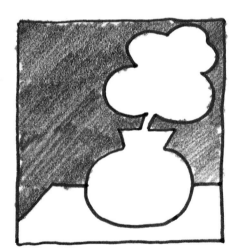

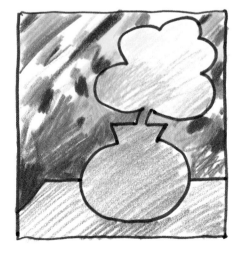

All compositions have negative space, but sometimes it's not very obvious, as in this example. The square border creates shapes between the frame and the subject as well as between the individual objects in the picture. Let's look at a simple example of this principle in the picture (above) of the vase on a table.

When none of the shapes are colored in, you will most likely see a vase on a table—that is, two objects (above center). Look more closely, however, and you'll discover that there are actually three elements in the composition, all with equal weight: the vase with the flower, the table, and the wall in the background. It is now simply a matter of deciding which element is most important to the artist. In the first example, it is the vase, in the second, the table, and in the third, the background. This may sound a bit abstract, but it could be, for example, that the pattern on the wallpaper is important to the artist and he or she wants to show how unimportant the vase is in comparison.

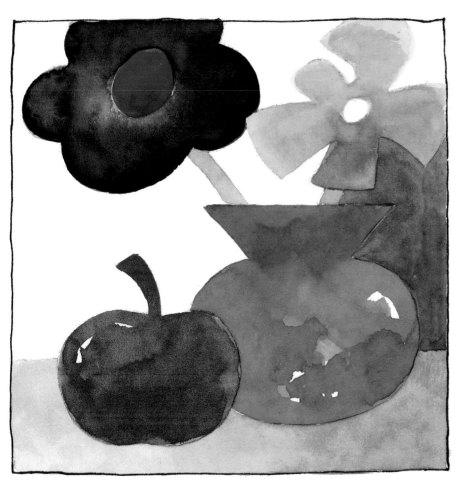

This simple example demonstrates the various results that can be achieved by simply emphasizing different shapes. To make clearer this somewhat unusual way of looking at things, the artist has emphasized the negative space in the bottom painting.

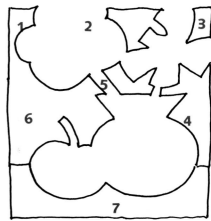

In the top painting, the apple and the vase are clearly in the foreground, and only a small area of the background is incorporated into the composition. In the bottom painting, on the other hand, the flowers serve solely to give form to the background shapes; they almost look like holes in the painting.

Even in less extreme examples, there is negative space, and you have to plan it carefully. Practice by creating simple compositions in which you pay attention only to the shapes that form between the objects. It is also interesting to look at famous paintings in this light. You'll be surprised at how much attention artists pay to the negative space—space that most observers hardly notice.

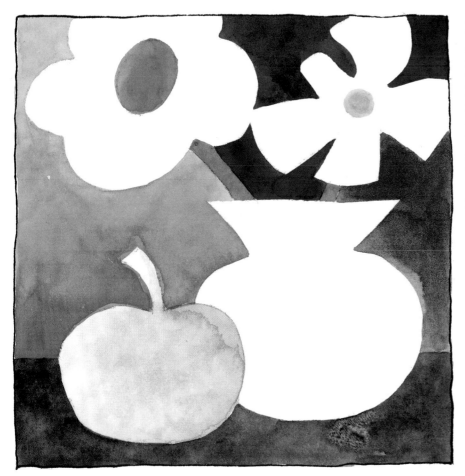

Achieving Depth

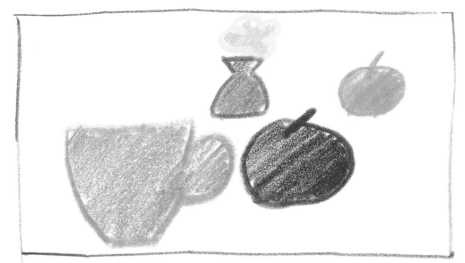

In addition to achieving the proper interplay of shapes, watercolorists naturally want to bring depth into a painting (provided it's not abstract). This doesn't necessarily have anything to do with perspective. Rather, it's a matter of defining space. Large objects, for example, seem closer than small ones. This effect is increased by overlapping. Let's look at an example of this.

In the picture above, you see four objects that are standing next to each other: two apples, a vase with a flower, and a cup. They're all the same size, they're all lined up in a row, and, frankly, they're all boring. Just by differing their sizes, as in the second picture, the artist can change the mood. The big cup is suddenly closer and more important, whereas the vase—which, in reality, is larger than the cup—fades into the background. In spite of this, however, the picture still lacks excitement. This is because the objects are distributed evenly across the surface of the painting.

Only by overlapping—as in the bottom picture—does the apple appear completely in the foreground and the cup all the way in the back. The picture not only gains depth, but its expressive element changes as well. The red apple is large and dominating, while the cup is unimportant.

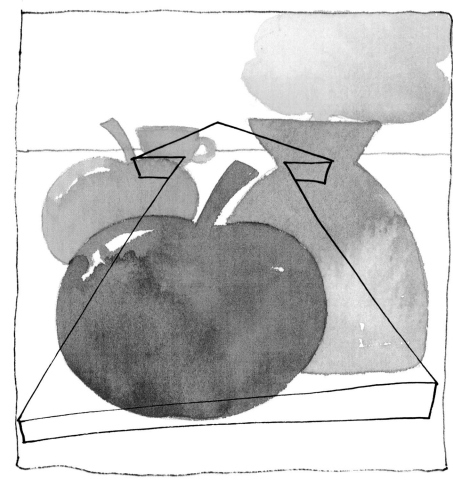

DISTANCE. The definition of space is an important factor to consider in a painting. In this example, nothing disturbs the eye in the empty foreground, so we can concentrate immediately on the objects in the painting, which seem distant.

CLOSENESS. Just the opposite is happening here. The eye has to look around the vase to see the other objects. The vase is very near, while the other objects appear quite distant.

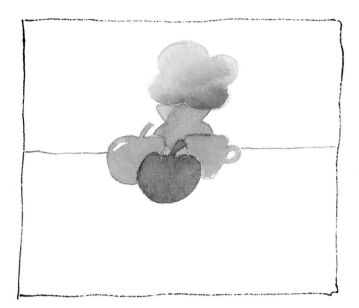

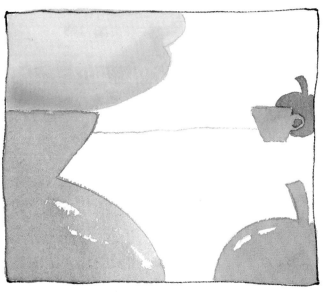

TRANQUILITY. The composition can determine whether the picture's mood is one of tranquility or tension. In this example, all the elements are arranged in similar sizes in the center of the painting. The picture appears peaceful and balanced.

TENSION. In contrast, the center of this example is empty, which somehow strikes us as odd. All the objects are pressed to the edges and cut off. The space between the objects creates tension.

Use these three shapes to experiment with different ways of defining space—for example, overlapping, changing the size of the shapes, or both.

You'll be amazed at how many different pictures and moods you can create.

Working with Light and Shadow

Observing light and shadow is important when you paint or draw from nature. You've seen how to simplify and reproduce a motif and how to place it in space and give it depth. Yet, even with all this, a picture can still seem flat.

Objects may appear to float in space rather than stand on a solid surface. To avoid this, you have to observe an object's shadows carefully.

Let's look at one of the basic shapes: the circle. If you simply draw a circle with a single line, it appears flat. As soon as you add light and shadow, however, the circle becomes a sphere. Light and shadow can make a drawn or painted object appear three-dimensional.

It is important to understand the difference between the two types of shadow: the core shadow and the cast

shadow. The core shadow gives an object form, while the cast shadow shows an object's position relative to the light source—that is, it indicates whether an object is standing, lying down, or floating. The cast shadow can also be very important for the expressive element of a painting.

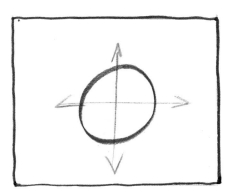 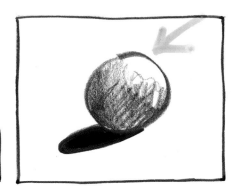

Let's look again at the sphere. You can see that each kind of shadow has a different value. The core shadow is always lighter than the cast shadow because it is illuminated by reflected light.

If the sun were always at the same elevation above an object, that object's cast shadow would always be the same length. Because this is not the case, however, the shadow always varies in

shape and length. The lower the sun goes, the longer the cast shadow becomes. You can see this very clearly in the three examples below.

In the first example, the light comes from the upper left, and the cast shadow is angled and not very long. In the second example, the light comes from directly overhead, resulting in a rather small cast shadow. A shadow like this one makes objects—for

example, those in a still life—seem as though they are standing firmly on a surface. In the third example, the light comes from the lower right. The cast shadow here is longer because the light source is much lower.

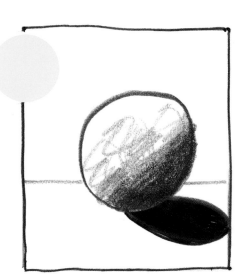 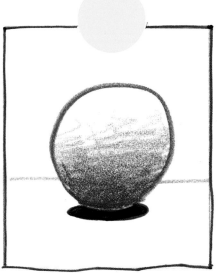 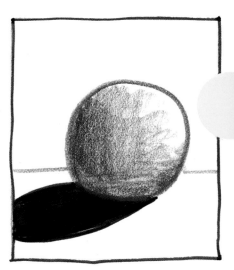

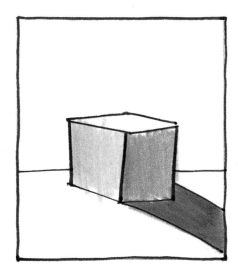 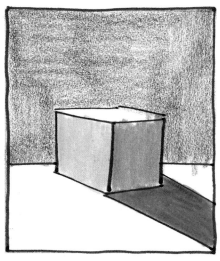 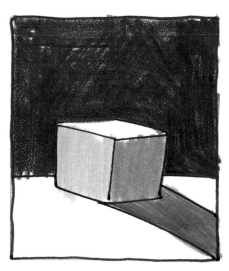

When drawing or painting a cast shadow, you must look at more than just the object and its light source. An object's surroundings also have an influence on the value and color of its shadow. As an example of this, consider the three boxes above.

Do the shadows in all three pictures have the same tonal value? Notice that when the background is light, the shadow seems much darker.

The darker the background becomes, however, the lighter the shadow appears. One factor remains the same: the cast shadow is always darker than the core shadow.

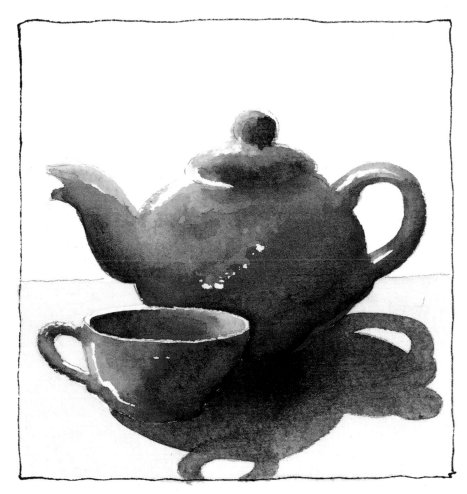

Place some objects in front of a light source and observe the shadows. Better yet, make a few simple pencil sketches in which you depict the tonal values. In this way, you can get a feel for the shapes.

Unfortunately, there is no recipe for determining the color of a shadow. There's not even a general rule. The reason for this is that shadows also reflect colors and are influenced by the light source that creates them. One thing regarding shadows is certain—a shadow is rarely solid black or gray.

In this painting of a teapot and cup, the light is coming from the upper left. The shadows are essential for modeling these simple forms. The artist used violet for the core shadow to soften the red of the teapot, and the cast shadow was adapted to the color of the table.

27

Everything in One Painting

In summary, let's have another look at the individual elements of composition in a finished painting (below). See if you can figure out the answers to the following questions:

Which basic shapes do you recognize? What factors contribute to the effect of depth? Does the painting have an element of tension, or is the composition balanced?

How do positive and negative spaces relate to one another?

The basic shapes are easy: the trees are circles, the house is a rectangle, and the mountains are triangles.

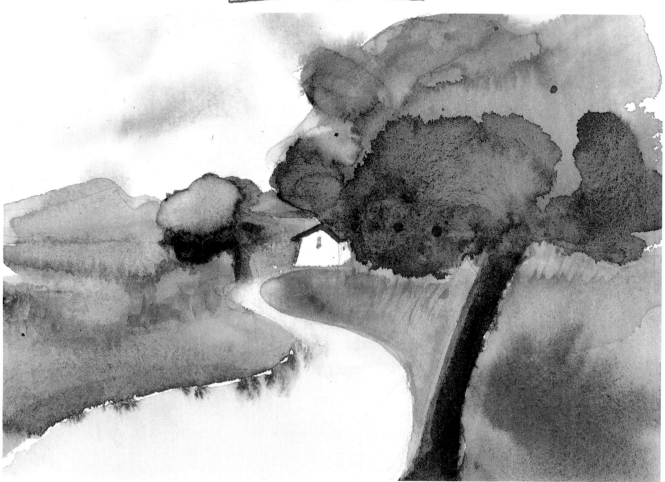

The differences in size and value contribute to the effect of depth. The lighter mountains are further in the background than the small house—they are even further back than the darker tree.

The trees lead the eye toward the outside edges of the painting, but the path leads it to the house; this contributes to tension in the composition.

If you squint your eyes, you can see the light and dark areas. The negative space is just as important to the composition as the positive space.

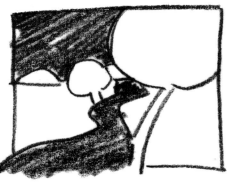

Light and shadow play important roles in this picture. The shadows give the flowers and vase a distinct form. You can also see the interaction of the positive and negative spaces.

This drawing shows just one way of varying the composition. Try expanding on the interplay among the shapes formed by the objects.

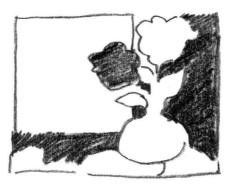

This is a simple beginning. You can break down the flowers and the vase into their basic shapes. In this example, the predominant shapes are the circle and the oval.

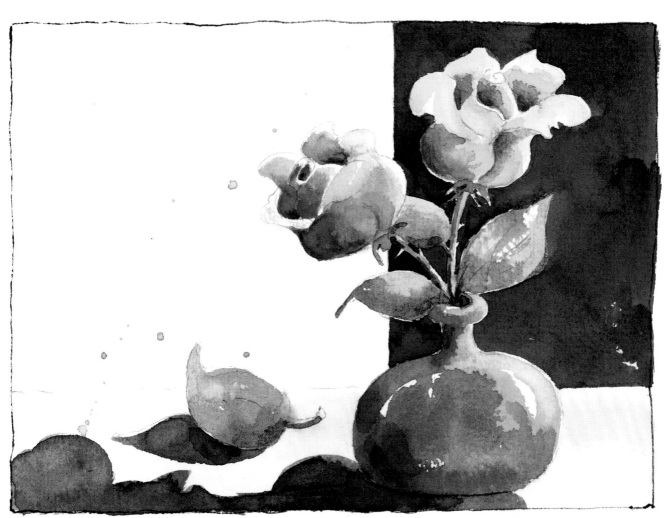

Shadows give the vase a three-dimensional effect. Some of the purple from the background has been pulled into the core shadow on the vase.

Notice that the cast shadows are not merely gray. They always involve colors that complement the motif. By using cast shadows in your paintings, you create the impression of objects standing or lying on a solid surface.

29

Sketches

Sometimes you feel like painting, but you don't know what to paint. It is at times like these when it's handy to be able to refer back to a pad in which you've sketched things that you've seen. These sketches may include people reading in a café, an especially beautiful building, a thunderstorm—the list is endless.

What exactly is a sketch? Actually, it's nothing more than a note to yourself in which you quickly jot down something you don't want to forget. It can be an idea, a motif that pops into your head, or a situation that you want to record. A sketch, however, can also serve as preparation for a larger painting. By making a preliminary sketch, you can try out different compositions or color schemes (see page 32).

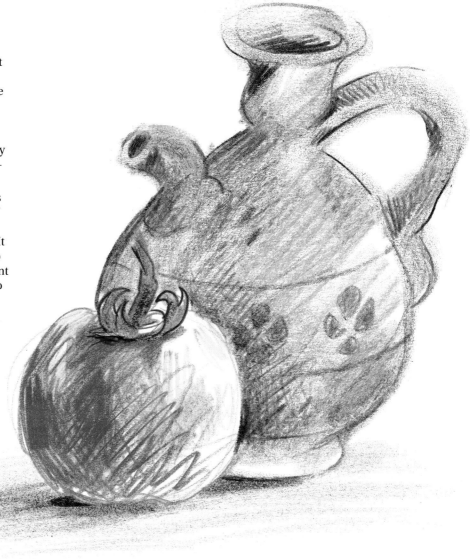

A sketch does not have to be exact, nor does it have to be polished. It only needs to serve as a reminder. This doesn't mean, though, that sketches always have to be secondary. Their spontaneity and rawness give them a certain charm of their own.

If you get in the habit of carrying a sketchbook everywhere you go, you'll soon have an abundant supply of ideas for future paintings. Moreover, you don't need any special supplies.

It doesn't matter, for example, what kind of paper you use. A pad that has a sturdy cover page is practical, or you can even use a notebook or a bound book with blank pages. The latter has an advantage because you won't need something extra to support your paper while you sketch.

The choice of pencils is up to you as well. Ordinary number 2 pencils work just as well as markers or ballpoint pens. Colored pencils are nice, as are colored chalks. A problem with colored chalks, however, is that they break and smear easily.

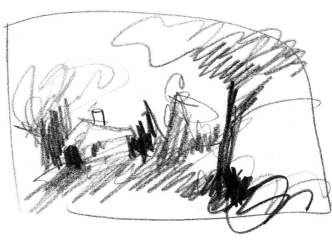

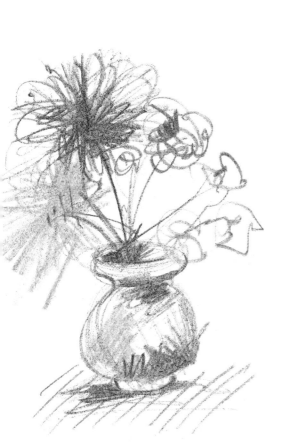

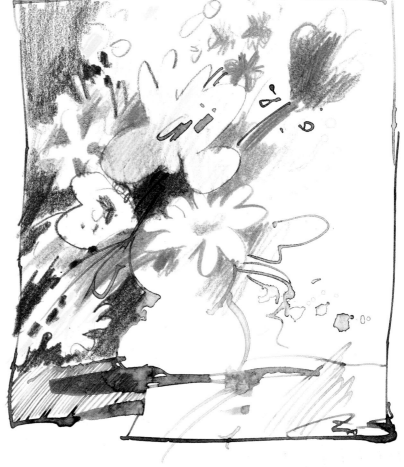

Here are a few examples. At the top of page 30 is a colored pencil sketch that I did because I liked the rather asymmetrical jug. At the bottom of the page are two quick pencil sketches that I did to note composition and tonal values of an outdoor scene.

Someday I want to make a watercolor painting from the sketch at the top right. For this sketch, I used colored pencils along with pen and ink.

I wanted to make a quick sketch of a bouquet, and the only tools I had with me were a red and a blue colored pencil. The result is shown above left. I could just as easily have used a ballpoint pen.

The sketch at the bottom was drawn on graph paper. I used colored chalk because it makes it easy to apply large areas of color. The hatching was done with soft colored pencils.

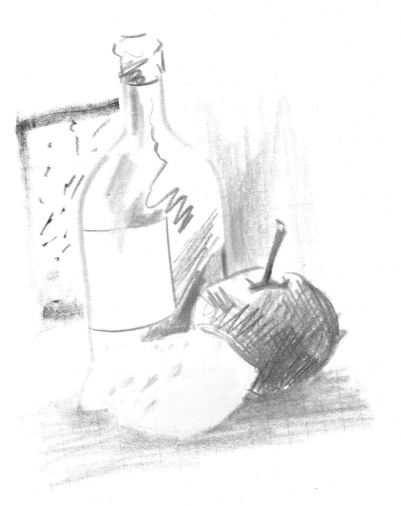

Painting a Simple Landscape

with Ursula Bagnall

Let's start with a few sketches. Even when you're painting outdoors, it can be helpful to make a few preliminary sketches to decide which elements you want to emphasize in your painting and which ones you can leave out. You can also see how the shapes relate to one another and determine the best composition to get your ideas across. If possible, you should do a few color sketches. This way, you can also choose a color scheme and test the tonal values.

(This is more a matter of figuring out a general color scheme rather than determining the exact colors you will use.)

Let's begin with a simple motif: a tree in the foreground, a house in the distance, and some mountains in the background.

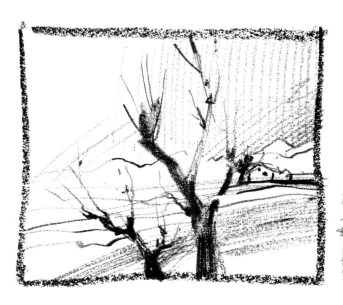

The first thing I do is make a pencil sketch. Here the tree is bare, but it dominates the picture. The house and the mountains are merely part of the background. This sketch establishes the composition and the tonal values.

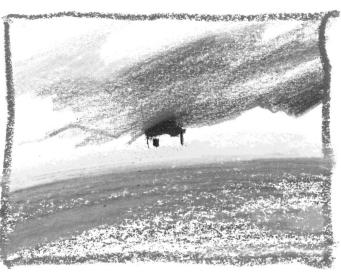

This sketch is done in colored chalk. I leave out the tree because I want to experiment with different color schemes.

This sketch is done with watercolors. Here I decide to paint in the leaves of the tree. Notice that the tree still dominates, but the red roof draws the eye toward the house.

This sketch is done with colored pencil. Here I emphasize the relationship between the bare tree and the dynamic sky. The small house is an important part of this picture. If I choose, I can later add more brush strokes to the tree.

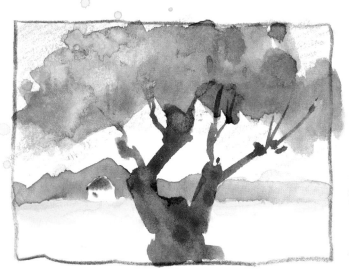

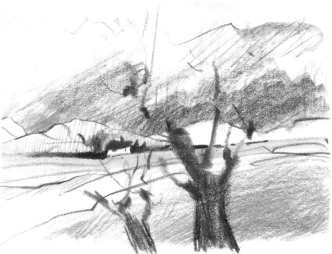

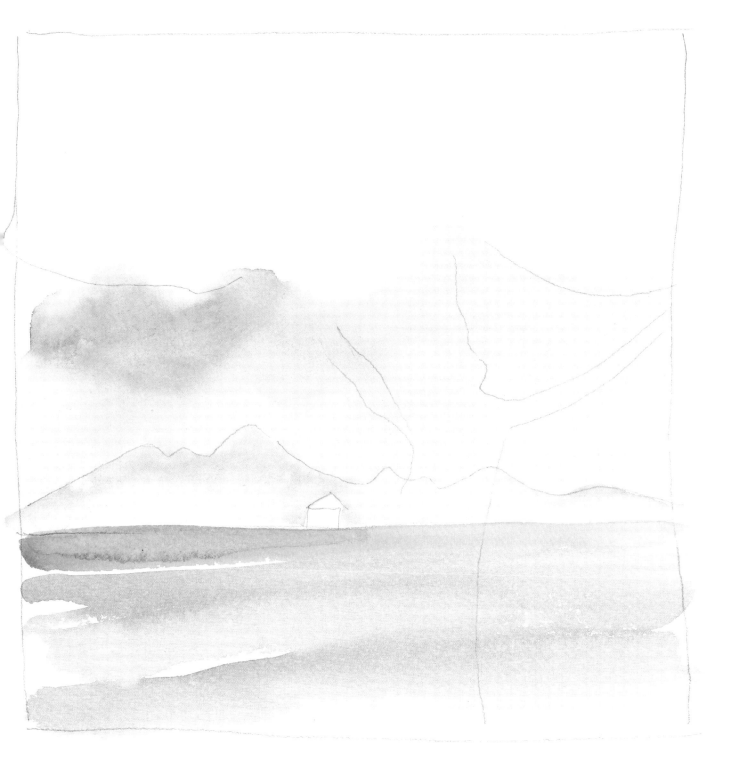

I finally decide to work with the third sketch: the small house and the tree with leaves. I am particularly interested in the colors of the leaves and the way they interact with the colors of the landscape. I limit myself to the colors in the expanded basic palette on page 10, and I use rough, 140-pound paper from a block and number 6 and number 10 round sable brushes.

The first step involves laying out the composition with light pencil marks. Then I wet the paper above the mountains with the number 10 brush and add liberal amounts of very wet violet. Next I paint in the mountains with ultramarine blue and then lay in the horizon with orange and the foreground with Hooker's green. I recommend not beginning with dark, unthinned paint because it's very difficult to go back later and correct areas that are too dark.

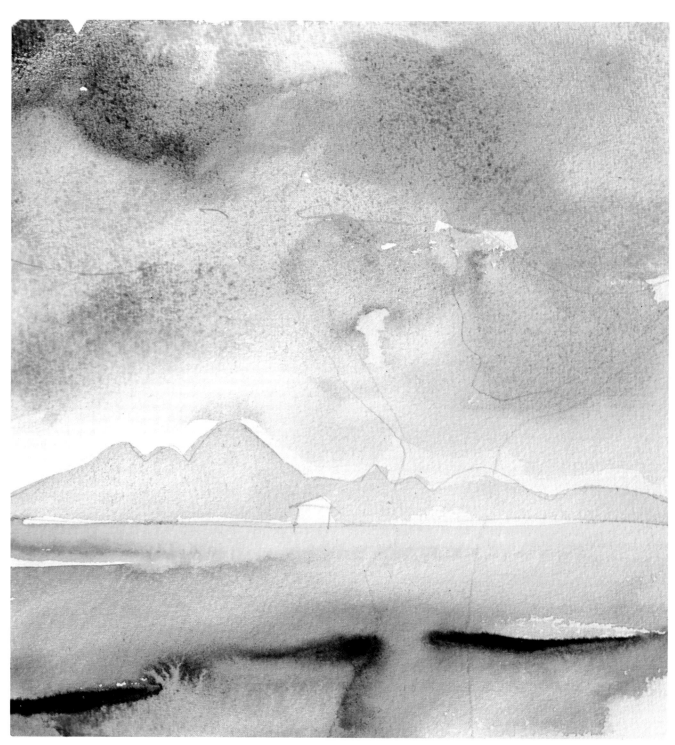

The next step involves intensifying the colors. I strategically place a dab of Hooker's green in the foreground and let it flow toward the bottom. As I do this, I rough in the area where I will eventually paint the tree trunk. I also paint in the green of the leaves. I like the way the leaves almost become part of the sky, so I keep the cloudlike texture. I also rough in the mountains, but, at this point, I haven't decided on a final color for them.

I like to use paper palettes for mixing colors. This way, I can experiment with various color combinations, and I often discover things that I wouldn't have dared on the actual painting. A few of these mixtures are shown here; some contain quite interesting textures.

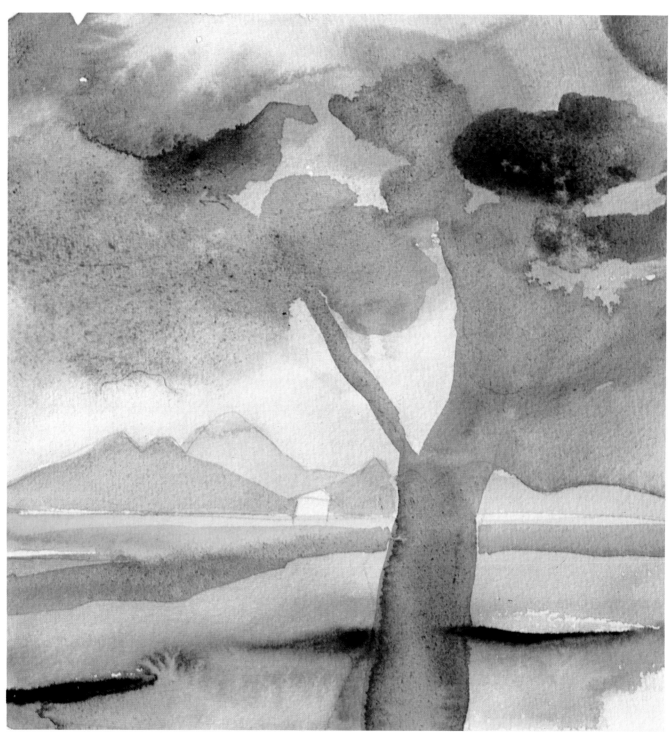

The white of the house is an important element in this painting; it draws the eye toward the house. To further emphasize the house, I make the mountains behind it even darker. The tree trunk is starting to take shape, but I leave it unfinished until the very end so I can determine exactly how dark to make it. I experiment, instead, with the negative space in the background. I still like the way the treetop blends into the sky, so I dab some yellow into the leaves to pull in some of the orange-yellow of the horizon. Small areas of alizarin crimson give the leaves even more life.

You have to be very careful not to get so caught up in the details that you lose sight of the overall composition. Also, remember to wash out your brushes and change your water frequently; otherwise, you can get muddy areas in the painting.

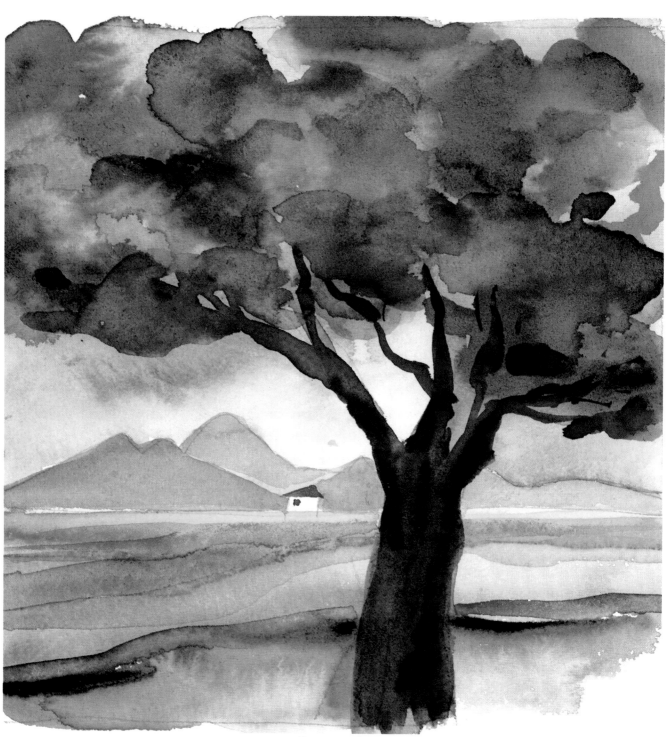

The last step involves polishing the details. You should do this after the previously applied paint has dried. The treetop needs to be livelier, and the trunk needs to come further forward, into the foreground. Sometimes I carefully add water to areas where the paint has already dried and add more paint. The new paint mixes with the old in those areas where I've added water, but it doesn't touch the dry areas. As a final step, I use cadmium red to paint the roof.

The tree branches are particularly well suited for experimenting with brush strokes. You can make thin, thick, crooked, or straight branches by merely altering your stroke (refer to page 15, if needed). As you can see in the example at the left, you can get beautiful, warm browns by mixing alizarin crimson with Hooker's green.

A Few More Tips

You can make many different compositions using the same motif. Here are a few tips on how to do this.

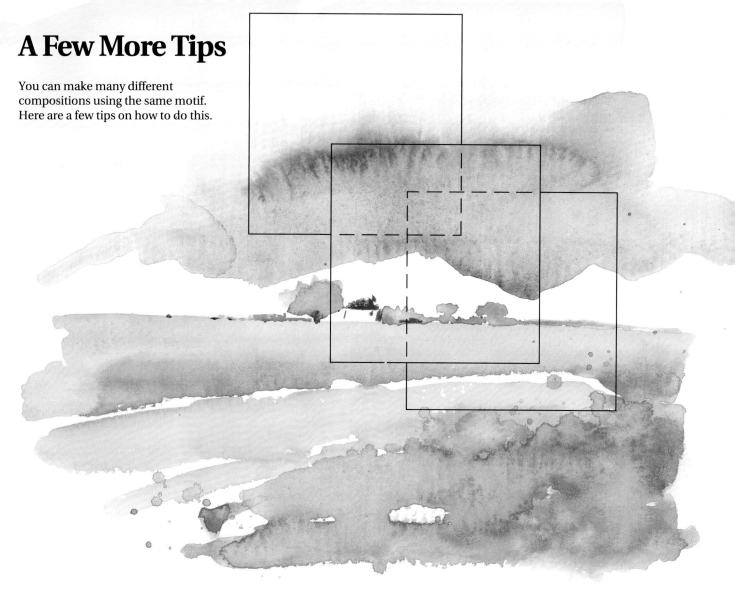

As the colors change, so does the mood of the painting. If you replace the dark colors with bright, warm hues, this gloomy thunderstorm becomes a cheerful summer day.

If you feel that you've ruined a painting, take a good look at it before you throw it away. Often you can get new pictures from portions of it, or sometimes the portions will give you ideas for new paintings.

You can intentionally leave white areas as elements in a painting. This is shown here in the mountains and the white streaks in the meadow. I drew in the house with colored pencils. Remember, there are no "rules" in art; you can do anything you like!

Painting Flowers

with Gerlinde Grund

Flowers have long been a favorite motif in all kinds of painting. Watercolors are especially suited for flowers because the brilliant, flowing colors and delicate blends allow you to capture the essence of a bouquet, a single flower, or even an entire field of flowers.

I recommend that you do a few studies before you attempt to paint flowers.

You can see a few examples below. The shapes that form between flowers and between petals are very important because they contribute to the fullness and liveliness of a bouquet. These shapes give individual flowers depth and three-dimensionality.

Sketch the basic shapes and let the plant form itself. Try not to get caught up in unimportant details. Try to capture the smell of the flower as well as its shape.

The white of the paper is especially important when painting flowers. Even if a flower isn't white, white areas can add brightness and shimmer; they make a painting fresh and lively. I like to leave a lot of white space while I paint because it seems easier and more spontaneous than using liquid frisket.

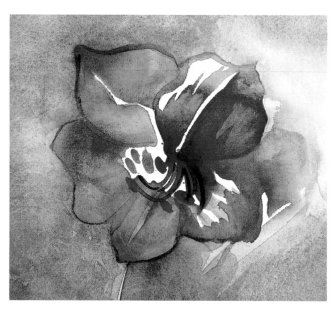

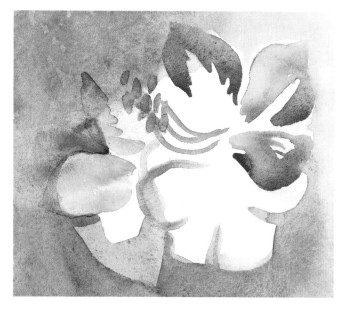

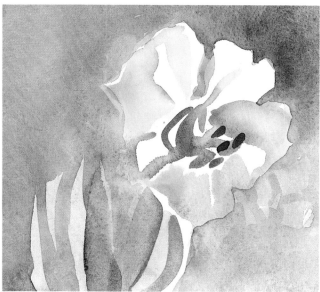

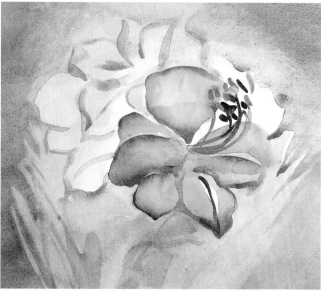

In watercolor painting, you start with light colors and work your way to dark colors. The reason for this is that watercolorists usually don't use an opaque white paint, so they can't go back and lighten things later.

First, I make a few sketches to get a feel for the plant. (In this, and all subsequent examples, I've used the basic palette described on pages 10 and 11.)

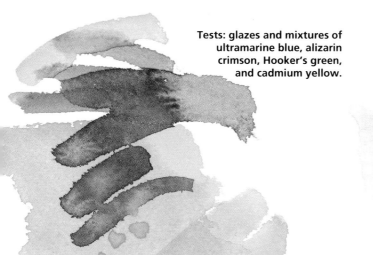

Tests: glazes and mixtures of ultramarine blue, alizarin crimson, Hooker's green, and cadmium yellow.

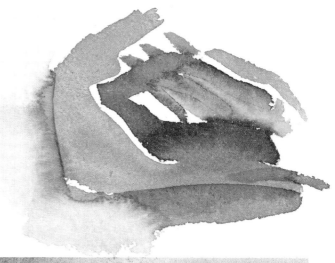

I do my warm-ups on the same type of paper that I plan to use for my final painting. In the above example, you can see how the colors react: how they look next to one another, how they look on top of one another, and how they run into one another. I've tried out a few glazes and then sprayed water on them to see the effect.

I look at the tonal values of the flowers, as well as the shapes. I try to determine the light source, which colors dominate, and which ones are good for shadows.

After preparing these studies, I decide to paint a fragrant amaryllis. I want to capture the essence of the flower as a whole—not try to re-create each individual petal. I paint the background first, leaving the white areas along the edges of the plant. The wet areas of the petals blend softly with the background. I like the contrast this creates between the blended areas and the hard lines.

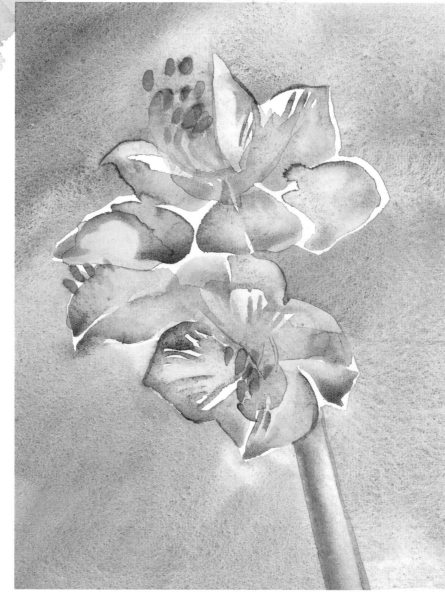

Working wet-in-wet, I paint the background with ultramarine blue and Hooker's green. At first, I leave out the somewhat stocky stem of the amaryllis; I add it after the background has dried. The highlight gives a lightweight effect to the stem.

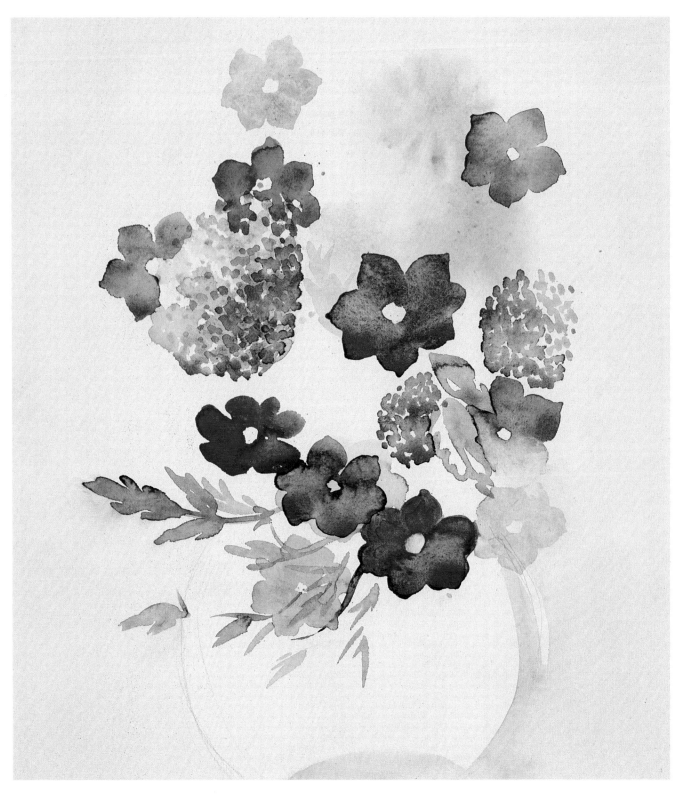

I received this colorful bouquet as a gift, and I thought it would be worthwhile to preserve it in watercolor.

If you want to paint a bouquet, a preliminary study of individual flowers can be helpful because you can capture the essence of the plant more quickly. Remember, though, that in your finished picture you want to capture the overall mood of the bouquet rather than paint each bloom. Squint and look at a bouquet: the individual flowers will disappear, allowing you to concentrate on the light and dark areas of the composition.

On a wet background, I begin to sketch out the anemones and daisies. Here I use alizarin crimson and cool reds—that is, I mix ultramarine blue with the red. I also rough in the purple flowers and the green leaves to get an idea of the overall composition. The glass vase isn't important, so I just lightly indicate it.

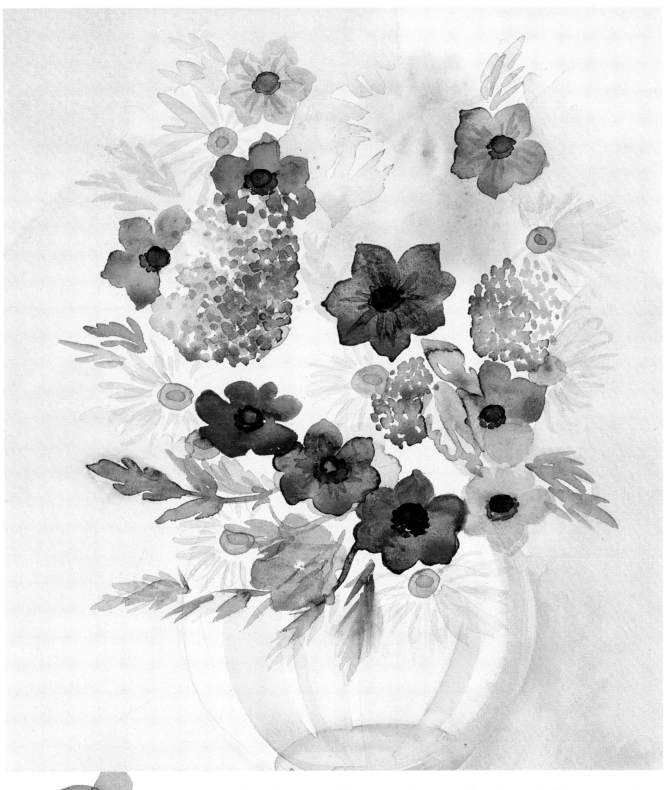

I leave the centers of the daisies white and then add yellow to them. I also complete the anemones and work the green of the leaves throughout the entire bouquet. I like to allow parts of my paintings to dry and then go over individual areas with a transparent glaze. I also like to paint partially over areas that I've left white.

This technique builds up layers of paint and creates the impression of intricate leaves and fragrant flowers. You can see this effect in the example at the left.

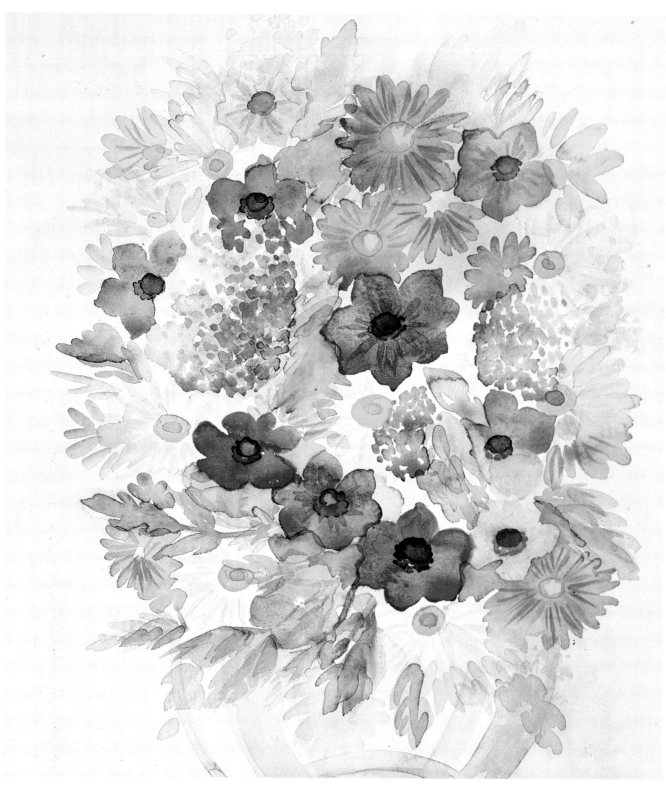

There are no rules to follow when you're painting flowers. You can achieve an astonishing degree of detail, or you can experiment with shapes and colors. Use your imagination. Remember, there's no law that says you have to paint an exact replica of the original.

Here I've thickened the entire bouquet and added dark accents. Now only the background is missing. I don't want to leave it white, but I also don't want it to dominate the painting. Because the picture has already dried and because I have to paint the background around the subject anyway, I have time to think about what to do. I am considering light tones so that the bouquet will retain its freshness.

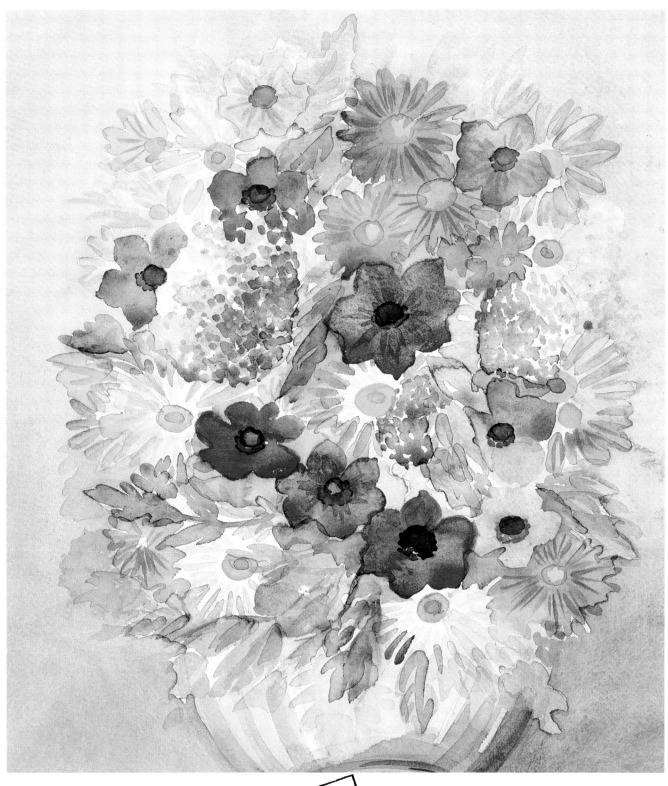

I cut two angles out of thick white paper and lay them around the picture like a frame. In this way, I can cover up and get a better feel for the painting. I decide on a background of delicate yellow that becomes darker toward the bottom (very thin Hooker's green and alizarin crimson).

The movable frame is useful for viewing specific portions of a painting.

Painting a Village

with Karlheinz Gross

Every artist has a different way of looking for subjects; I like to go around with a Polaroid camera. The photographs I take enable me to paint my watercolor pictures in the comfort of my own home.

I discovered this rural motif one winter. I liked the way the ruggedness of the half-timbered building on the left contrasted with the gracefulness of the building on the right and the way the dome and the bare tree were positioned between them. The foreground consisted of gray cobblestones. I didn't photograph the foreground because I knew I would want it to be bright—perhaps yellow-green—and I would want to paint leaves on the tree. I made an on-site pencil sketch to determine the arrangement of the dark and light areas.

I frequently use both photographs and drawings as a sort of "memory crutch" for future paintings. At home in the studio (or in the hotel room if I'm traveling), I try to put the motif on paper the same day I sketch it. This way, I can make the first "cosmetic" corrections; for example, I leave out things that bother me, such as telephone poles, street signs, parked cars, or—as in this example—boring gray foregrounds. Sometimes I also add things that aren't in the original, such as a tree, a hedge, or even an entire building. Cézanne is supposed to have once said, "We shouldn't copy nature, but rather work parallel to it." These words have real meaning for me today.

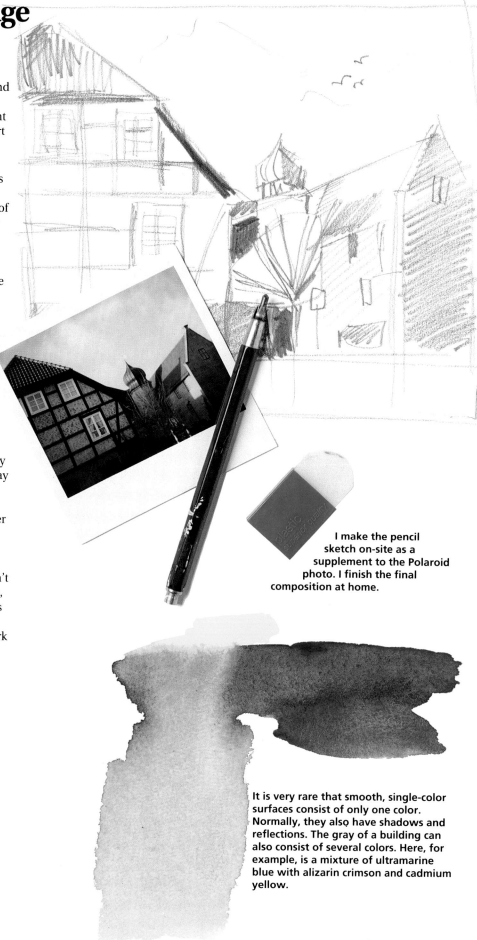

I make the pencil sketch on-site as a supplement to the Polaroid photo. I finish the final composition at home.

It is very rare that smooth, single-color surfaces consist of only one color. Normally, they also have shadows and reflections. The gray of a building can also consist of several colors. Here, for example, is a mixture of ultramarine blue with alizarin crimson and cadmium yellow.

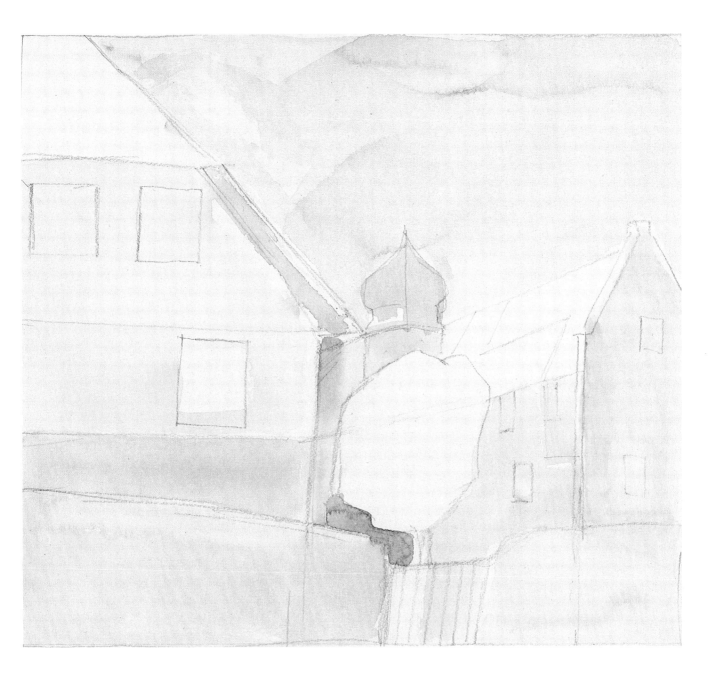

During the painting process, I'm always glad I'm a painter and not a photographer. The motif, the sketch, and the photo are only means to an end. I use my imagination to create a composition I like. You have to learn to separate yourself from the physical object you're painting and try to re-create your impressions of it. Whether painting outdoors or at home, as I do, the creative person will always decide whether to leave out the telephone pole, to paint the ugly pink door yellow ochre, or to make the facade cement rather than stone.

I begin a painting by applying the colors to the pencil sketch. In this case, I limit myself to the six colors of the basic setup. I use tube paints and a plate or lid as a mixing surface (of course, you can use a palette if you wish). I like to apply my paints as quickly as possible. As I'm applying the first strokes, I decide where the dark areas are going to be because they will dominate the painting when it's finished. In this painting, the emphasis will be on the dome, the gate, and the overhang of the roof.

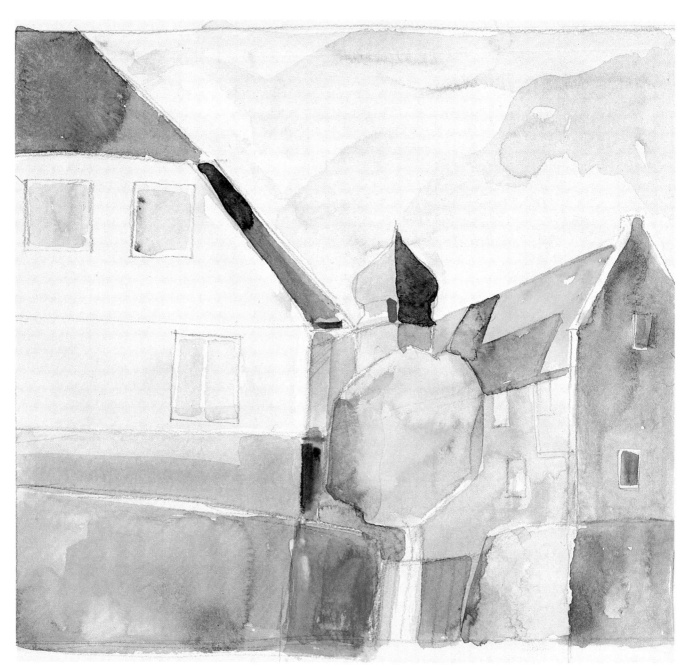

Always work from light to dark. Keep in mind, however, that you have to be very careful when you're using dark tones at the beginning of a painting because you can't remove them later and they're almost impossible to lighten.

I mix my paints directly on the plate or on test paper, which is, of course, the same type of paper I will use for my final painting. At first, I don't go into much detail. It's more important to lay in the areas of color as well as the dark and light interplay among them. You can see that there is already more depth between the buildings and that they are becoming more three-dimensional. I've also started to work on the sky, and I've begun to emphasize the windows.

Be careful that you don't paint over the same spot too often because the colors get muddy very easily. In extreme cases, the paper can become rough, resulting in ugly areas.

Before I start, I try out a few colors and mixtures on the same type of paper I plan to use for the final painting. Here, you can see a few practice glazes. Often these simple warm-ups can give me some new ideas for the painting.

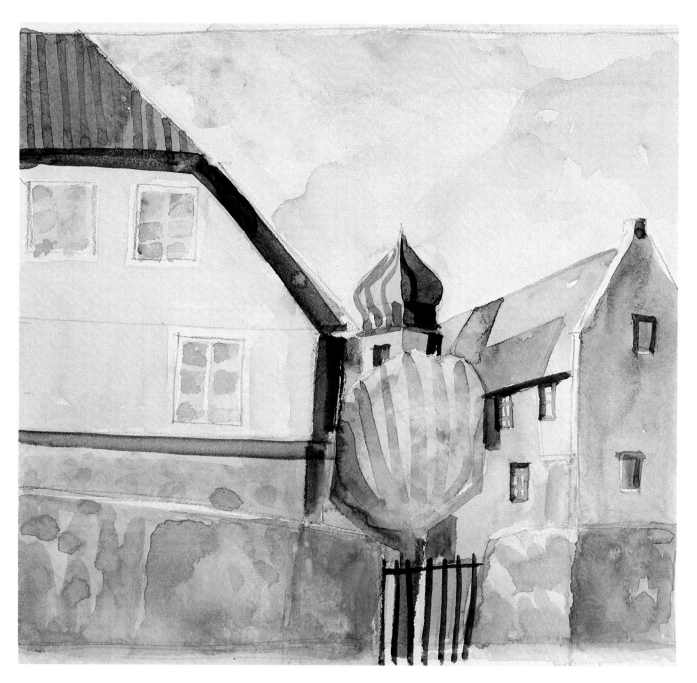

I recommend getting up every now and then and looking at your picture from a distance. This way, you prevent yourself from losing sight of the overall painting and becoming caught up in unimportant details.

As part of my equipment, I always carry a blow dryer to speed up the drying process and tissues to blot up excess paint or paint that is too wet. I also change the water frequently while I paint because clear colors can only be produced with clear water.

The next step in developing this painting involves emphasizing the shadows as well as such details as the structure of the tree. As I do this, I let each layer of paint dry before I paint on top of it. This technique allows me to capture the straight lines and sharp edges of the buildings. Painting wet-in-wet results in fuzzy lines and blurry colors, which would have been inappropriate in this painting.

The sky strikes me as having too much of a single color. For artistic reasons, I want to repeat the yellow in the tree and the hedge, so I let the sun "shine" through the clouds.

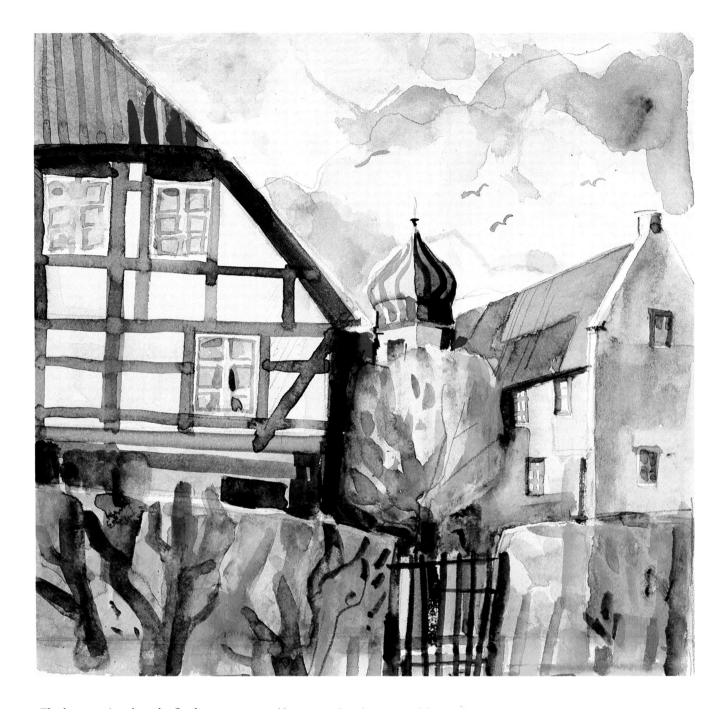

The last step involves the final polishing of details, which should always be done on a dry background. Here you run the risk of overdoing the picture or, as some say, "painting it to death." Unfortunately, there are no general indicators to tell you how much polishing is too much. With practice and experience, however, you'll get a feel for when to stop.

The trees' somewhat static limb structure bothers me because it clashes with the framework of the house. That's why I paint over the tree with yellow. It's obvious that I am using the simple structures of the tree and hedge as a contrast to the orderly framework of the house. The different

red hues—cool and warm—of the roof compensate for this contrast and help pull the composition together, as does the yellow in the hedge, the tree, and the sun. To create a few accents in the sky and incorporate it into the picture, I add some birds. I draw them in with a pencil, but I can also use very thin paint.

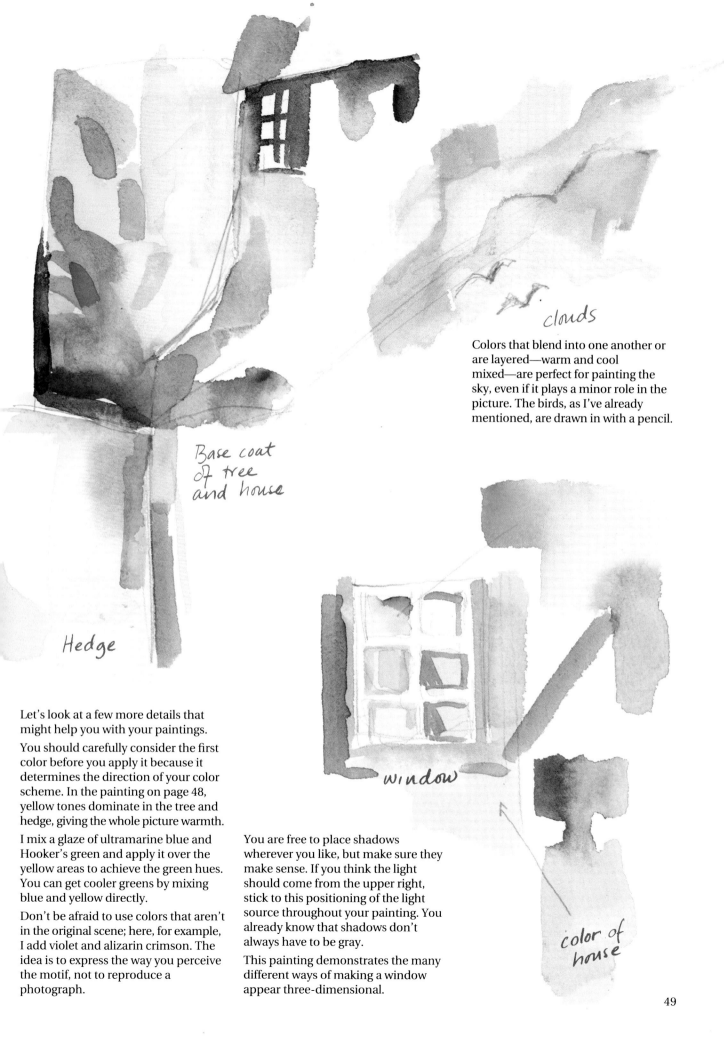

Base coat of tree and house

Hedge

clouds

Colors that blend into one another or are layered—warm and cool mixed—are perfect for painting the sky, even if it plays a minor role in the picture. The birds, as I've already mentioned, are drawn in with a pencil.

window

color of house

Let's look at a few more details that might help you with your paintings.

You should carefully consider the first color before you apply it because it determines the direction of your color scheme. In the painting on page 48, yellow tones dominate in the tree and hedge, giving the whole picture warmth.

I mix a glaze of ultramarine blue and Hooker's green and apply it over the yellow areas to achieve the green hues. You can get cooler greens by mixing blue and yellow directly.

Don't be afraid to use colors that aren't in the original scene; here, for example, I add violet and alizarin crimson. The idea is to express the way you perceive the motif, not to reproduce a photograph.

You are free to place shadows wherever you like, but make sure they make sense. If you think the light should come from the upper right, stick to this positioning of the light source throughout your painting. You already know that shadows don't always have to be gray.

This painting demonstrates the many different ways of making a window appear three-dimensional.

Painting a Still Life

with Beate Weber-von Witzleben

At first, you might think that still lifes are not suitable for watercolors. Paints that run and are difficult to control can be a nuisance when the shapes are supposed to be "correct." It's too easy for accidents to happen. Such a view of watercolor may have some truth in it if you're thinking of the traditional still life with a fruit bowl, a vase, and a pitcher. Yet, a still life can be something else: an intensive observation, a discovery of light, color, and form, an individual creation of a motif, or an interaction among all these elements. Shapes and colors can be combined and composed in all possible ways, and you have the opportunity to observe your motif from all angles—you can change it or even the light that shines on it. Moreover, a still life doesn't have to consist of stiff ceramic bowls and lifeless glass vases. You can use your imagination and have fun!

In this painting, for example, I don't put much emphasis on the vase. It is a thick vase, but I merely indicate it. The important thing for me is to try to capture the fragrance of the bouquet.

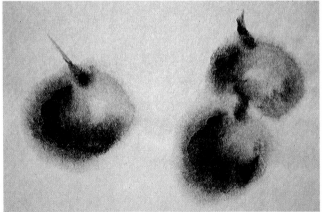

The three pieces of fruit at the left are also a still life. You can spend a lot of time painting fruit, and it will always look different. This time, I try an unusual technique—an oriental painting method that requires Japanese paper. The type I use is handmade.

I use this technique to paint the two plums at the right. If you apply the paint in varying degrees of thickness on wet paper, it dries with delicate edges. This is what produces a unique "plasticity." The direction of light is also important to consider, as it gives the fruit its roundness. Try to capture the roundness and plasticity of fruit with watercolors; with practice, it's not difficult.

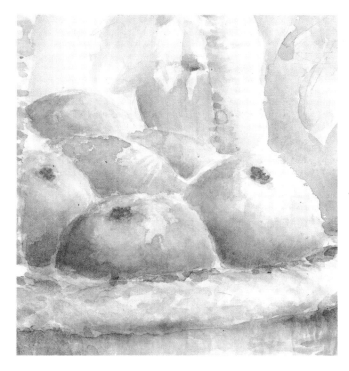

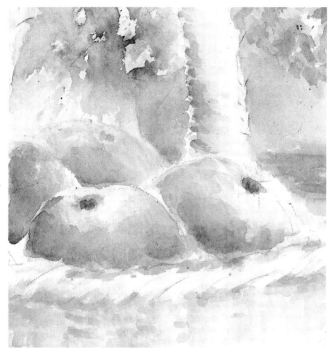

Here the same motif appears twice, and each time it has a different mood. This basket of apples was on my balcony, and I felt more like painting the apples than eating them. I sketch the basket and the apples rather precisely, and then I begin to paint with warm hues. You don't have to sketch out a motif first, however. You can just take a brush and start painting.

I feel like painting the same fruit in different colors. In the example above, I replace the warm yellows and ochres with cool violets and blues. Now the apples look as though they've been sitting in the refrigerator rather than lying in the sun.

There is more than one way to paint a motif. Experiment beforehand with cool and warm hues and with delicate and bold colors.

At the right is a different kind of still life. I set up the bottles and pitchers and do the usual sketches. After a while, however, it seems as though the shimmers and reflections take on lives of their own. I squint my eyes and imagine the objects in terms of their basic shapes. To capture their transparency, I pull the background into the foreground throughout the painting. I also repeat shapes and leave areas of white, a strategy that intensifies the feeling of transparency.

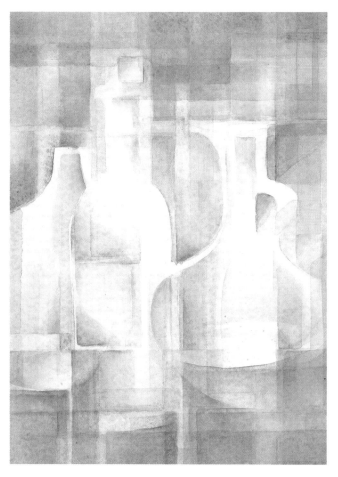

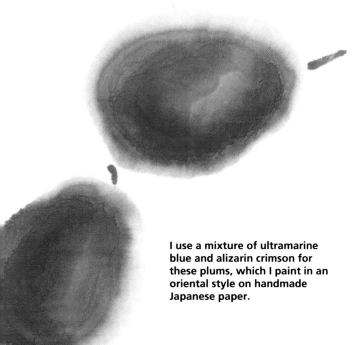

I use a mixture of ultramarine blue and alizarin crimson for these plums, which I paint in an oriental style on handmade Japanese paper.

51

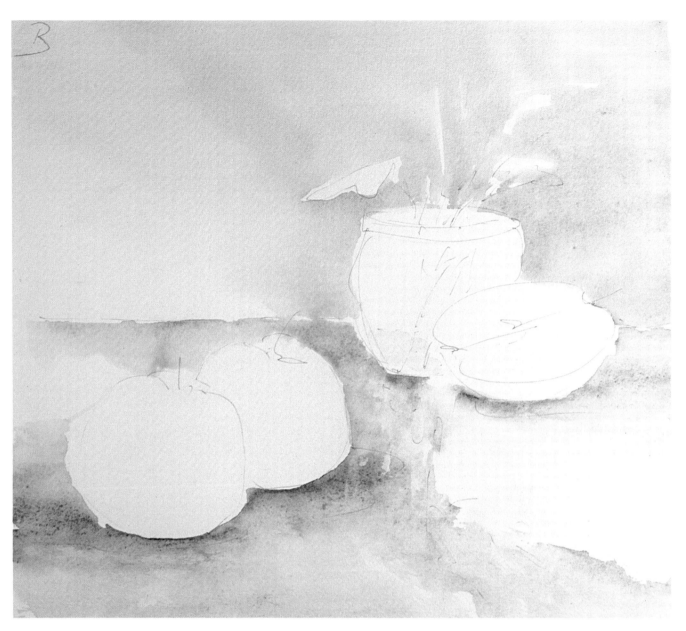

You can create a still life from almost any arrangement of objects. You can use stones, straw, pieces of wood, or items you find on the beach. You can also find motifs in the garden, knitting box, kitchen, or playroom.

At harvest time one year, for example, some children gave me several small apple tree branches, which I arranged in a water-filled jelly jar. Then I added two appetizing, ripe, whole apples and half of another apple. Together these objects became the basis of the still life I share with you here.

Don't begin with motifs that are overly complicated—a few pieces of fruit and some cuttings from a tree are sufficient for a start. Soon your "painter's eye" will take over and begin to compose. Bizarre, withered branches and the shadows they cast, the round shapes of apples, a few water drops or a reflection on the surface of a table—all can provide inspiration to paint, and you can re-create the significant impressions they make without much difficulty. You should first decide whether you want to paint realistically or to express the way you feel when you look at the subject. I decide that for my still life I want to use delicate, cool colors to convey a peaceful, reflective evening mood after a busy day of harvesting.

Here my palette consists mainly of ochre, alizarin crimson, ultramarine blue, violet, and umber. I begin with a few small sketches, changing the sizes or shapes of the objects to fit the composition. Next, using pencil, I lightly sketch the motif directly onto the paper. It doesn't matter whether these marks remain visible; they make the painting livelier.

Working wet-in-wet, I rough in the surface of the table, sketching out the water drops, shadows, and reflections. I do the same with the background.

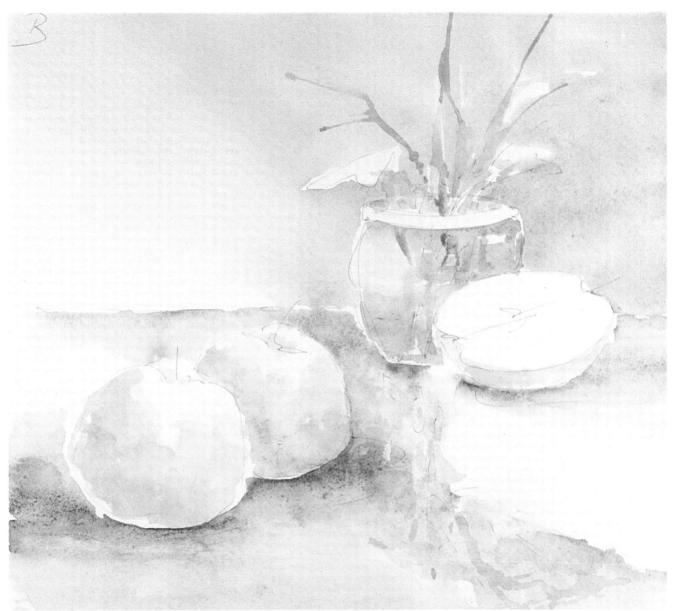

Left and above: The "blown" branches
Right: The "pressed" shadows

I choose ochre for the table and violet and umber for the shadows, but I don't prepare a mixture of violet and umber on the palette. Instead, I thin both colors separately, dip half the brush in one color and half in the other, and then apply the paint with a twisting stroke. I use a soft one-inch brush for this technique, which enables me to achieve unusually interesting areas of color.

Using a round number 12 brush, I apply the final colors of the apples (crimson, ultramarine blue, some ochre, and a small amount of violet mixed with a touch of umber). I paint with gentle strokes, leaving the white areas untouched.

I mix all the colors except ochre to produce the gray-blue for the branches' shadows. Instead of painting in the shadows with a brush, however, I press them in: that is, I apply the paint to a separate sheet of watercolor paper and lightly press it onto my painting. The advantage of this technique is that the shadow doesn't look "painted"—it looks wispy.

For the branches, I use a method that flirts with coincidence and relies on the runny quality of watercolors. I apply very thin paint to the paper and blow the paint in the desired direction. Instead of painting with a brush, I'm painting with my breath!

53

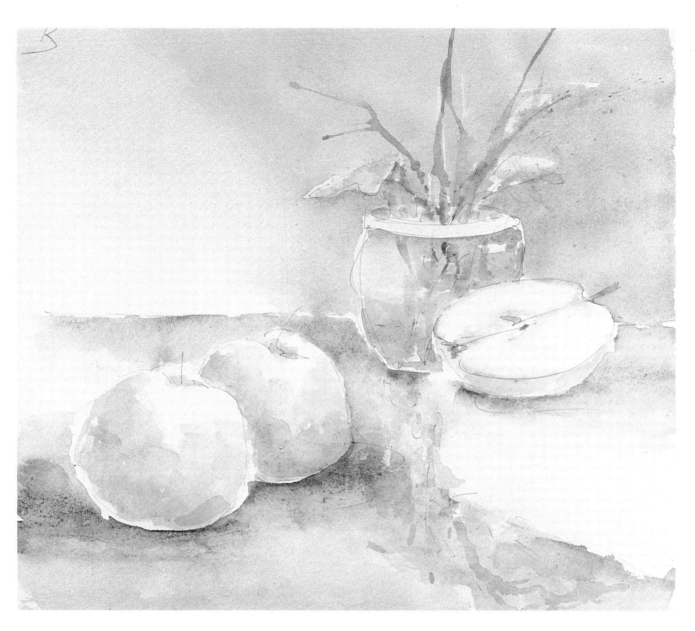

I apply the yellow, red, and orange of the apples with thin paint in light glazes. The core and cast shadows are essential to give the impression of three-dimensionality. I mix a violet out of ultramarine blue and alizarin crimson and add thinned ultramarine blue and umber. I emphasize the cast shadows so the apples clearly appear to be resting on a solid surface (see pages 26 and 27).

For the jelly jar full of water, I use ultramarine blue and a blue-green that I mix from ultramarine blue and ochre; I simply add a touch of this blue-green to the foreground. I produce the highlights and reflections in the glass by using violet and allowing a small amount of white paper to show through.

To achieve sharp forms like these, let the paper dry before you add new colors, and only wet the areas that you want to paint. I like to work with a blow dryer so the paint dries more quickly, enabling me to work without any long pauses.

Try to paint the same motif on two different kinds of paper—for example, once on very smooth paper and once on rough paper. You get completely different textures, and even the colors have a different effect. You'll also see that not every kind of paper is suitable for every motif.

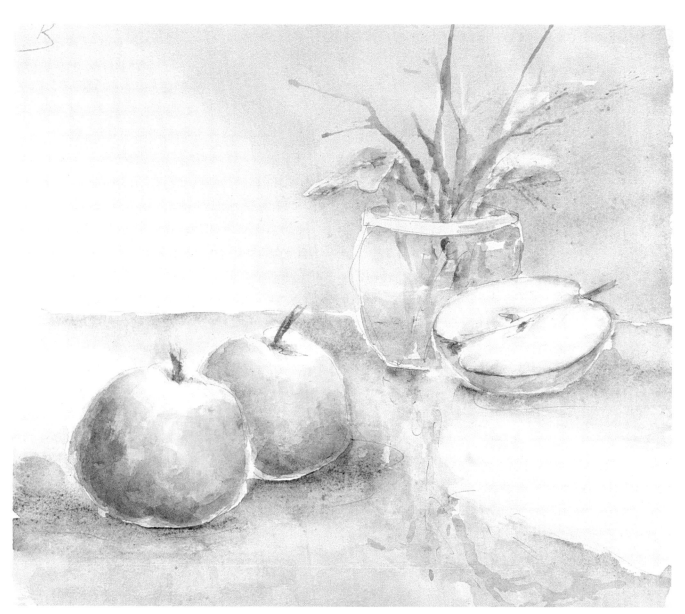

Now the finishing touches can be added. The apples and the apple half are gone over with thin—but unmixed—paint in the colors yellow, red, and blue, so as to intensify and enhance them.

The bare branches and the leaf are pulled into the composition by using stronger colors on them, and the composition as a whole is pulled together by the reflections on the surface of the table. I use chrome yellow to add intensity to the apples and the dried leaf. To achieve the cool overall effect, I use the tip of the brush to dab a little cerulean blue on the glass and the water drops, as well as—very lightly—on the apples.

At the right is a suggestion you can work with: a totally different, less exact apple. To paint it, I use loose patches of color, working wet-in-wet at first and then adding thinned paint to an almost dry background.

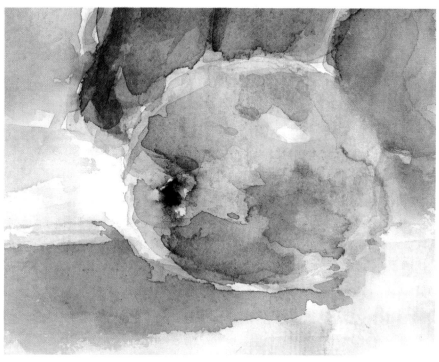

Experiments

Every artist has a unique style and often knows a few technical tricks that can be of help. These tricks can include combining other media with watercolor. First and foremost, painting should be fun. Nobody can stop you, for example, from introducing oil paints into your watercolor paintings, if you want to. Without going too far afield at this point, the artists here will show you how to achieve satisfying effects with some very simple materials.

For example, you can scratch into wet paint to create light streaks; if you paint over these scratched areas, they fill with paint and darken. If you scratch with a crow quill pen and ink, depending on how wet the paper is, the ink will run and blend with the paint. In the picture at the top, the artist used blue ink; in the picture at the bottom, black ink.

You can produce interesting textures by drawing with a nearly dry felt-tip marker that has water-soluble ink (as another painter did here for the trees).

If you do this on a wet background, the line varies in value because the ink comes off the marker tip in varying amounts.

By spattering paint onto a wet background, you can come up with some interesting patterns. You can make the thickest spatters by dipping a toothbrush into the paint and rubbing your thumb across the brush so the paint falls onto the painting. Use a piece of paper to cover areas that you don't want to spatter.

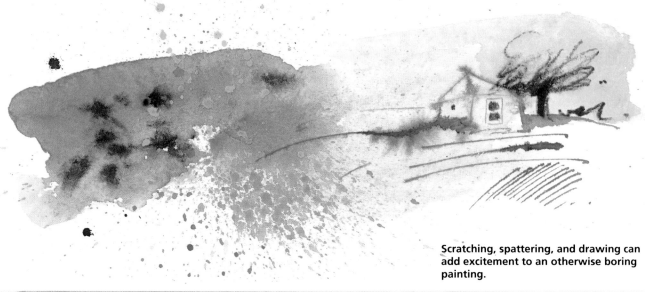

Scratching, spattering, and drawing can add excitement to an otherwise boring painting.

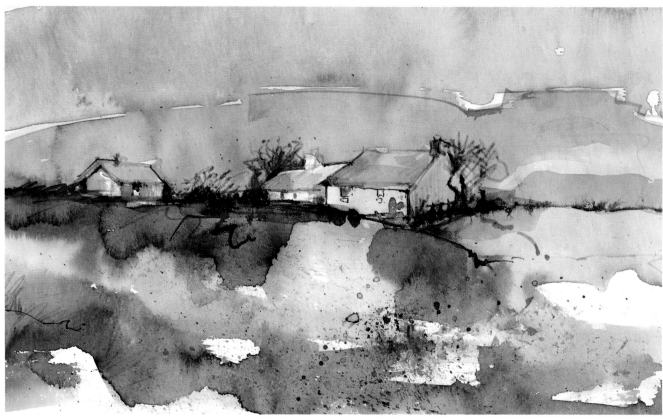

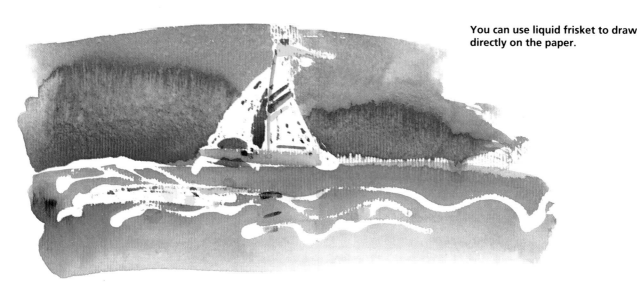

You can use liquid frisket to draw directly on the paper.

Using Liquid Frisket as a Drawing Tool

You have learned how to use liquid frisket to cover areas that you want to remain white. A variation is to paint a color on the paper first and then protect this color with frisket. After you paint a color over the frisket, the frisket can be removed, and the color underneath is untouched. Above, a painter applied frisket directly on the paper, rubbed it off, and then added the accents and the body of the boat. This technique is especially useful for painting plants and landscape areas such as fields.

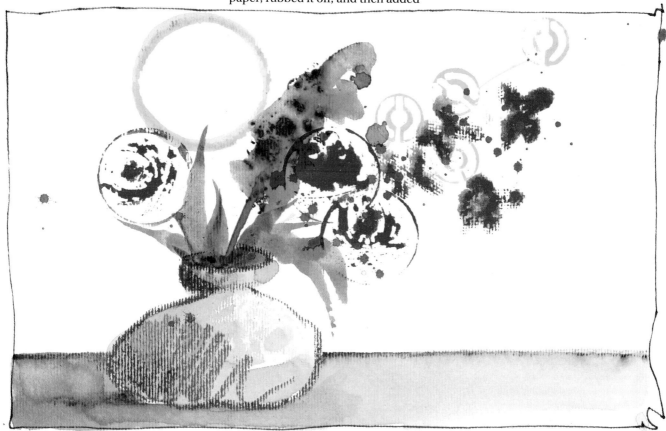

Pressing

Several different techniques were used for the picture above. First, the artist drew the outline of the vase with chalk on heavily textured paper; this texture creates an interesting, broken line. Then watercolor was used to paint the leaves, the blue flowers, the vase, and the table. Then the artist found various container caps, dipped them in paint, and pressed them onto the paper. Soda bottle caps were used for the red circles, and paint tube caps were used for the small yellow circles.

Because paint doesn't stick evenly to surfaces like these, you can produce textures and patterns and continue to work with them. Use to your advantage the "accidents" that occur.

A Few More Tips

Although you can't make many corrections when you're using watercolors, sometimes you can turn a mistake to your advantage. In any case, you should let a painting sit for a while before you try to "rescue" it when a problem occurs. After a day or so, you can look at the picture from a fresh perspective, and perhaps you'll notice worthwhile features after all. Sometimes parts of an unsuccessful painting will give you new ideas. You can rework portions of a painting and use them in a collage, or you can discover interesting textures simply by washing off the old paint.

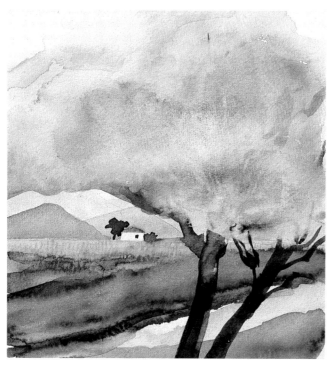

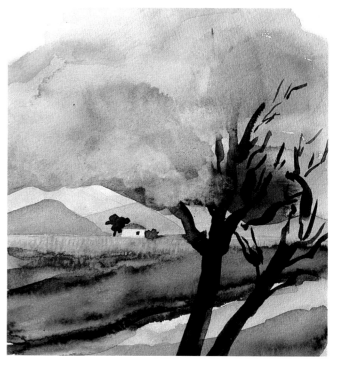

The artist's first attempt at the painting on page 36 was unsuccessful (see above). The plan had been to paint delicate tree branches, but the background was much too dark in the spot where they were to be added. As a result, the branches didn't turn out as well as expected and the sky looked mundane, but the artist did like the foreground.

The solution: rewet the branches and the sky with a thick brush and rub off the paint, then dry the surface with a tissue so no water would run into the mountains. You can see the result of these steps in the picture at the upper right.

Notice also that the tree blends with the sky, giving the impression that the sky itself is the treetop. Inspired by this, the artist made the bare tree sprout leaves. The way the tree appears to melt into the sky is quite appealing, so this effect is emphasized by the addition of violet and yellow to the painting.

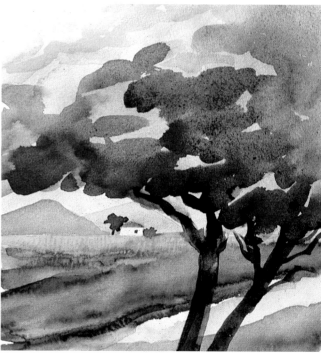

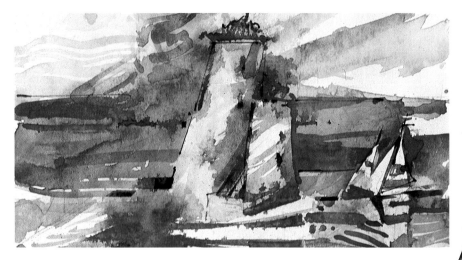

This painting was to have been a peaceful seascape, but it began to grow turbulent, with the sky and the water becoming so similar that it was difficult to distinguish between them. The artist didn't like the painting, but the part that included the lighthouse and the boat was too attractive to throw away, so it was cut out of the larger picture.

After trying out different color combinations and washes on a big sheet of paper, the artist set the cutout on top of it, varying the position until a successful composition was created. Try this exercise once, for example, with a tree that you cut out. You'll be amazed at how many interesting variations you can produce using such a simple motif.

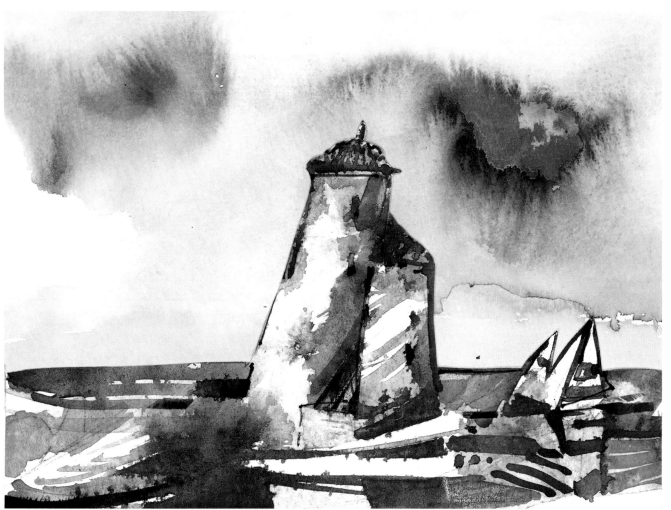

Motifs for Inspiration

Now that you've been introduced to the most popular watercolor techniques, tips, and experiments, you're probably ready to get started. Yet suddenly you ask yourself, "What should I paint?" Maybe there's no fascinating thunderstorm lurking in the distance, or you're fresh out of bouquets. Just for this reason, a few photographs have been included here for you to use as sources of ideas. You can paint portions of them, vary their shapes and colors, or combine different motifs.

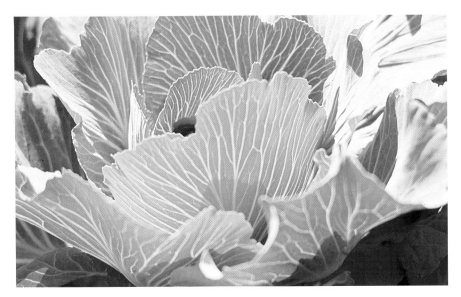

This head of cabbage has an almost abstract effect—a piece of art in itself. This is an excellent motif for experimenting with glazes because each layer of the vegetable forms new hues and lines. You could start out working wet-in-wet and gradually paint sharper shapes. You can even exaggerate the greens and yellows in the middle as a contrast to the large areas of blue.

Here is something unusual for you brave painters: a stack of old wooden crates. In this picture, the hues and mixtures, with areas of blue that crop up unexpectedly, are more important than perspective and preciseness. It's probably best to begin with light hues and gradually work your way to the darker areas. Add the final shapes last on a dry background, paying particular attention to the nuances in color. You'll find browns and ochres as well as yellows, reds, light greens, and light blues. Exaggerate and experiment with abstractions. Do a few sketches to determine what to emphasize and what to leave out. Remember to reduce the objects to their basic shapes.

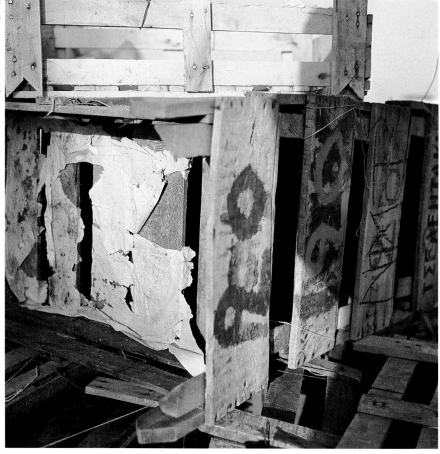

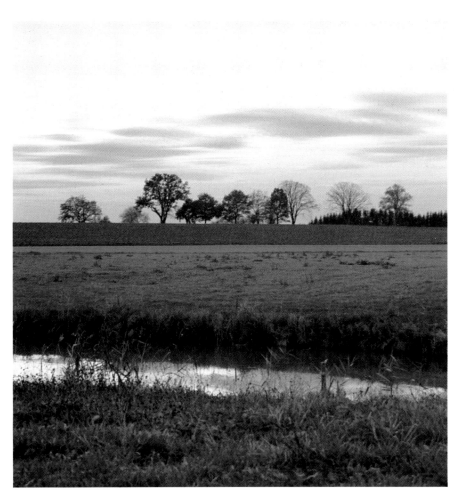

The simplest motifs are often the most effective. The large areas of this picture—the meadow, the sky, and the water—can be painted in first. The interplay among the large, open areas, the delicate blades of grass in the foreground, and the trees in the background is particularly interesting. You can pull the grass further into the foreground and experiment with scratching and spattering.

You might want to leave the sky white and gently add a hint of clouds with blue. Would you rather turn the scene into a thunderstorm? It's up to you. The sky's reflection in the water is also interesting—it looks as if a piece of sky has fallen on the meadow.

The still life below isn't simple, but it's a good one for practice. Again, don't limit yourself by trying to reproduce it faithfully. Light and shadow are important so that the apples appear to sit firmly on a solid surface. Have a look at pages 26 and 27 if needed.

Here are some unusual flower motifs. The background is important for the lively overall effect of the picture, but it shouldn't overwhelm the flowers in the foreground. If you were to develop the picture above, you could leave the paper white for the petals and experiment with the shadows. In working with the picture at the right, try experimenting with the contrast between the focused and unfocused parts of the flower itself. It's a good idea to do a few color sketches first to figure out a composition. Perhaps you can create some variations, as Gerlinde Grund does on pages 38 and 39. Have fun!

Glossary

cast shadow
A shadow created when an opaque object blocks a light source. The size and shape of the cast shadow are influenced by the position of the light source.

collage
A technique of creating a composition by gluing down pieces of paper, fabric, or other materials. Pablo Picasso (1881-1973) and Georges Braque (1882-1963) developed this technique into a serious art form, and it also found favor among the surrealists and the dadaists.

core shadow
The shadow found on an object. The core shadow is always lighter than the cast shadow and gives an object its shape and three-dimensionality.

Expressionism
An artistic movement of the early twentieth century that was a reaction against the Impressionist movement. The Expressionists were more interested in the expression of the inner experiences of the artist than in the aesthetic enjoyment of art.

fresco
A technique of painting on wet plaster. The term comes from the Italian word for "fresh." *See also* **wet-in-wet.**

glaze
A thin, transparent layer of paint applied over dry paint. Because the glaze does not completely cover previous layers of paint, it is possible to achieve delicate mixtures and subtle nuances. Glazes are particularly suitable for painting in watercolors because of the transparency of the paints.

handmade paper
Paper that is made by hand rather than by machine. The best watercolor paper is made by hand from linen rag, which is boiled, shredded, and beaten to a smooth pulp. The pulp is run over a fine screen, dried, and pressed. This technique is still practiced, but the paper is very expensive.

Impressionism
An artistic movement that originated in France in the mid-1860s. The name comes from an 1872 painting by Claude Monet, *Impression: Sunrise.* The Impressionists were particularly interested in light and color. The artist is led by his visual impressions and attempts to re-create the mood of a subject. The favorite motifs of the Impressionists were animated scenes from daily life and bright landscapes.

Japanese paper
Handmade paper from Japan that exhibits silklike delicacy, as well as great strength. Japanese paper is imitated in the West, but the product from the West does not exhibit the same durability.

liquid frisket
A kind of masking fluid that can be rubbed off when dry. In watercolor painting, it is especially useful for masking areas of white.

negative space
Space that forms between objects in a motif or between the motif and the frame.

oriental painting method
A kind of painting technique that is bound closely with oriental philosophy and the ancient art of lettering. Artistic ability is based on brush control and the beauty of the brush stroke. The artist uses a combination of brushwork and certain shapes and motifs to depict areas, lines, textures, shapes, and tonal values. Artistic expression, therefore, exists only in nuances that artists achieve by varying their brushwork. Mastering this brushwork is an advantage for the watercolorist because it provides a means to achieve new effects.

pigment
An organic or inorganic substance that provides color. Pigments are usually mixed with a binder to produce paint. The binder in watercolors is gum.

plasticity
The effect of three-dimensionality. Just as the sculptor can model a three-dimensional figure, the painter can use techniques to achieve the illusion of space. *See also* **core shadow.**

positive space
Space occupied by objects in a motif.

tonal value
The degree of darkness or lightness in a color, measured on a scale of gradations between black and white.

transparency
The quality of watercolor that allows it to modify the color onto which it is applied without completely covering it. *See also* **glaze.**

wash
An application of diluted paint that covers large areas of paper. A wash is laid from top to bottom on wet paper with a thick brush or a sponge.

wet-in-wet
A technique of working with fresh paint on a wet surface. Working wet-in-wet allows the artist to achieve soft blends and delicate contours.

wet-on-dry
A technique of applying fresh paint to a dry surface. Working wet-on-dry results in clear shapes and sharp edges.

Index

Credits

Getting Started in Watercolors
Recommended Readings

Edin, Rose. *Watercolor Workshop/1.* How To Series. Laguna Hills, California: Walter Foster Publishing. 1989. #HT213.
ISBN: 0-929261-23-2.

Light, Duane R. *Watercolor.* Artist's Library Series. Laguna Hills, California: Walter Foster Publishing. 1984. #AL02.
ISBN: 0-929261-04-6.

Peterson, Kolan. *Watercolors Step-by-Step.* How To Series. Laguna Hills, California: Walter Foster Publishing. 1989. #HT205.
ISBN: 0-929261-47-X.

Powell, William F. *Watercolor & Acrylic Painting Materials.* Artist's Library Series. Laguna Hills, California: Walter Foster Publishing. 1990. #AL18. ISBN: 1-56010-060-5.